HISTORIC HAUNTS OF SAVANNAH

MICHAEL HARRIS AND LINDA SICKLER

Haunted America

Published by Haunted America

A Division of The History Press

Charleston, SC 29403

www.historypress.net

First published 2014

Second printing 2015

Manufactured in the United States

ISBN 978.1.62619.195.2

Library of Congress Cataloging-in-Publication Data

Harris, Michael, 1957- author.

Historic haunts of Savannah / Michael Harris and Linda Sickler.

pages cm

Includes bibliographical references (pages).

ISBN 978-1-62619-195-2 (paperback)

1. Haunted places--Georgia--Savannah. 2. Ghosts--Georgia--Savannah. I. Sickler, Linda.

II. Title.

BF1472.U6H366 2014

133.109758'724--dc23

2014023433

CONTENTS

Acknowledgements 5
Introduction 7

1. A Haunted Hanging: Alice Riley and Richard White 11
2. Sledgehammer: Rene Rhondolia 31
3. Shady Corner: The Sorrels and Molly 43
4. At Death, We Do Depart: Willie and Nellie 59
5. Ghost Justice: Skee and Justice 67
6. Bones, Burials and Ghosts: Tomochichi and Oglethorpe 85
7. High Noon: James Stark and Philip Minis 107

Conclusion 127
Notes 131
About the Authors 141
About the Contributors 143

ACKNOWLEDGEMENTS

What started out as a modest book on Savannah ghost stories between an independent researcher and a newspaper reporter soon turned into a multifaceted project involving a total of five people with diverse talents.

As a result, numerous friends and family members deserve a heartfelt thanks for reading and offering invaluable suggestions on various chapters and illustrations in the process of writing and producing the book and offering encouragement to everyone involved in the project. They are as follows: Sarah Langham, Casie Edblad, Tobi Brock, Shannon Hicks, Kristina Prince, Pam Hicks and Jerry Hicks.

The staffs at the Georgia Historical Society and Lane Library at Armstrong Atlantic State University were helpful for the use of their facilities.

Our good friend George Hicks took an early interest in the book and agreed to offer his considerable talents as principal illustrator, adding a provocative interpretation to the ghost stories included in the book. Along with the talents of illustrator Wes St. Claire, these remarkable illustrations have elevated the book to new visual heights.

Don Clark Jr. was kind enough to lend his considerably talented hands to take photographs. We are grateful for Don's friendship and keen artistic eye.

Michael would also like to thank his daughters, Sarah and Casie, and his friend Michael Bledsoe for his usual encouragement and humor through the writing process. The cast at Ghosts and Gravestones Trolley Tour, Savannah, was a continual source of support.

Linda would like to thank her husband, Charlie Sickler, for always insisting she could write a book and encouraging her to do so. Her grandsons, Caleb and Callen Sickler, always provided a diversionary source of inspiration.

George would like to thank his lovely wife, Shannon, and his daughters, Gillian and Jordyn, for their enduring support during the project. He also thanks Wes St. Claire for his masterful visual interpretation of the three stories he illustrated.

And finally, a special thanks goes to Jerry Hicks for his long distance, eleventh-hour photographic expertise that allowed George to capture the image that ultimately became the cover of this book.

INTRODUCTION

A city lost in time...
 Savannah is one of the most charming and beautiful cities in America. Its majestic, moss-filled oak trees and stunning architecture in picturesque city squares make it stand out as one of the true jewels of the South.

Savannah is also a city steeped in history. It boasts the largest historic district in the country, attracting thousands of people every year to feast on its cuisine, history, charm and visual delights. It is a city lost in time.

But it is not merely what's aboveground that brings people from all over the world every year. Savannah is reputedly one of the most haunted—if not *the* most haunted—cities in the United States.

People who are fascinated by ghosts flock to the city to hear about the "spirited souls" who wander through the old buildings and sacred burial grounds. They want to hear spooky tales, tour haunted buildings and cemeteries, at night, usually, and most of all, see a ghost!

There are dozens of ghost stories to be told about Savannah. Nearly every house and building has a resident ghost or two as the city is literally built on the dead. Walk through any square or drive down any street in the oldest section of the district, and you can be sure you are traveling on the buried remains of long-forgotten and nameless souls from the past.

One of the most common questions people ask, of course, when they venture off to hear about Savannah's ghosts is: "Are these stories *really* true?"

It is only natural to ask the question in an age dominated by the objective facts of science.

Virtually every human culture from the past has its ghost tales. One would be hard-pressed to find a group of people who did not harbor their own brand of restless souls wandering about haunting the living. So why should we moderns be any different?

Despite our obvious differences from our past ancestors, it seems to be the case that, when scratched deeply enough, there is little difference when it comes to our relationship with the not-so-departed dead.

Some dead souls return to us in various ways. They simply will not go away.

There are numerous books about Savannah's ghosts already in print—some very good ones. So the natural question for any potential reader is, why read another one? The most pressing question for us was: why write another Savannah ghost book?

The first thing the reader should know is this is a book about *ghosts*, plain and simple—their uncanny and stubborn presence in their various Savannah haunts. Vampires, zombies, witches and the like, though interesting and scary in their own right, do not show up here.

Specifically, it is a book about certain Savannah ghosts and the fascinating and often tragic lives they led before their ghostly appearances in Savannah.

We think we take a different approach to the topic. Instead of offering explanations from science or popular opinion that attempt to *explain* why certain peoples' ghosts remain behind to haunt the living, we largely refrain from such explanations. Such views, while sometimes valuable, end up saying more about the person seeking ghosts than the actual ghosts themselves.

Explanations ranging from violence shed on a particular parcel of land (wars, murders, etc.) to physics (the ghost as the residual surplus of human energy forms) seem uninteresting to us in explaining this "phenomena of the strange," as we like to call ghost appearances.

If a *ghost* is an apparition of a dead person, then one of our primary objectives is to put the "person" back in the ghost.

Simply put, we offer a detailed exploration of the human lives of selected Savannah ghosts, unveiling a deeper understanding and appreciation of their stories. The ghosts we write about were people at one time whose lives were subject to similar hopes, dreams and desires that preoccupy us as well. We sought to put flesh back on their now-withered bones while telling their tales.

We set out to uncover the truth behind some of Savannah's most popular ghost stories in writing and illustrating this book. But that isn't our only goal.

The three "Ws" dominate the pages that follow: Who, What and Why. We do not, however, offer explanations for why they exist as ghosts. Their stories stand on their own to be told and retold, again and again.

Our focus is on the historical and cultural circumstances behind the *haunts*, on one hand, while foregrounding the actual *ghost stories* on the other. Both are equally important.

In five of the chapters, we explore well-established ghost tales. We have marked these stories in italics as a handy reference for the reader. Our subsequent discussion of them offers an expansion of these tales, and some of these tales contain authentic kernels of historical truth, as the reader will discover.

Included are some remarkable illustrations by two talented artists in our collection, as well as fine photographs to help the reader form a deeper appreciation of these tales. The result is a kaleidoscopic perspective on the ghosts and their tales.

Whether a person is a true believer in ghosts, a raging skeptic or somewhere in between, we think we offer something of interest for everyone who likes a good tale from Savannah's past.

So, come along as we explore the fascinating stories of some of Savannah's most haunted places.

CHAPTER 1
A HAUNTED HANGING

ALICE RILEY AND RICHARD WHITE

I would rather be a paid servant in a poor man's house and be above ground than king of kings among the dead.[1]
—Achilles to Ulysses

One of the most beautiful squares in Savannah is Wright Square. It was the second square built after Johnson and one of three James Oglethorpe and his Savannah settlers established in the first years of the colony.

Known as Percival Square back then, in addition to housing plots of land for the settlers to cultivate, it functioned as the judicial center of the town's activities. The courthouse and jail were located on the western side of the square. This magnificent and storied square was also ominously known as "hanging square," the place where the condemned met their fate on the gallows in the eighteenth century.

Knowing its past history, one cannot walk around it at night or on a bright sunny day without feeling, and perhaps faintly hearing, the cries, moans and groans of those who met their deaths dangling from the end of a sturdy rope.

One particular hanging, in fact, the first in the colony, is particularly haunting—full of intrigue, mystery and tragedy, as well as a good dose of sex and love. What follows is the true story that took place in 1734–35, which still haunts the square to this very day.

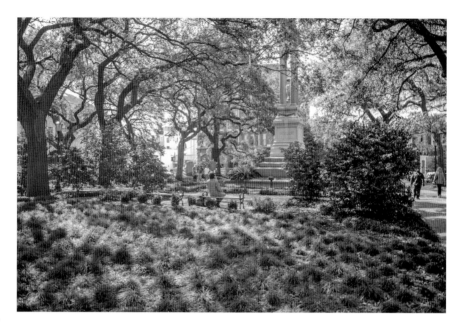

Old "hanging square," Wright Square.

VOYAGE TO AMERICA: PRELUDE

So this was seasickness.

Alice Riley managed to pull herself to the ship's rail where she retched. She had been warned the voyage's earliest days would be unpleasant, but surely this was something much worse. Could she be dying?

"No, lass, yer not dyin'," a kind-looking woman said as she pulled the girl upright. "It will pass in a few days as ye gain yer sea legs."

Alice certainly didn't want to die. She had embarked on the dangerous voyage to the New World because she very much wanted to live, and like a lady, too.

She'd wanted nothing more than to escape the dirty, smoky hovel she lived in and to leave the dank air of dirty lanes in the darkest and poorest corner of the city where she lived. She was dressed in her finest, but the wool of her skirt was faded and drab from too much wear.

Alice longed to feel the silken finery of a lady draped across her body, like the upper-class Irish women she had seen prancing about the street.

Staring out at the Atlantic Ocean in the dead of winter, she greedily searched the horizon for a sign of the new land to which she was sailing. It was a land promising her a future filled with a better life than she had known in Ireland.

She laughed slightly to herself. Alice was headed to Philadelphia, a popular port for Irish immigrants to America. It was still weeks away and felt like an eternity she couldn't fathom.

What would it be like? What treasures would the city hold in store for her?

Just as she was leaning on the bow of the ship pondering her fate, a flash of red caught her eye. She turned to see young Richard White, slender and muscular, strutting gracefully across the deck. The ocean's shifting waves and currents had not taken him down. He must be strong and able, she thought.

Feeling her gaze, Richard glanced at Alice, winked and flashed a knowing smile. There was something a little devilish about that smile, a bit of arrogance and daring that made him attractive yet dangerous.

Alice felt the blush rise across her face as she turned away. She had no time for the likes of Richard White. Sure, she would have three to four years or more of servitude to pay, but she would still be young when the time was up. There would be plenty of time to realize the dream of the new life she planned, and with a man of means in a land of plenty. Life was surely going to be good in her new home.

As she gazed out on the seemingly endless ocean with the cold, wet wind streaming across her cheeks, she saw strange apparitions on the horizon. They looked like ghostly human figures with distorted, menacing faces, as if to harm someone or something. As if to harm her!

She turned away for a moment and then looked out at the vast ocean again. The figures had disappeared as quickly as they appeared.

A chill ran down her spine and a sense of foreboding came over her like nothing else she'd felt before. She was uneasy but determined to stand firm against whatever tides turned against her. Little did she know what she was in for.

The Legend

The legend of Alice and Richard has been told with relish by generations of Savannah ghost tour guides, and with good reason. This story has it all—love, sex, violence, even a gripping courtroom drama. But is it all true?[2]

A woman named Alice Riley arrived in Savannah in 1734. She was an indentured servant, which meant she signed a contract to work for a master for up to seven years in order to repay her passage to America.

Unfortunately, she was placed with an ill-tempered, nasty, lecherous old man named William Wise. Among her daily duties, Alice had to bathe him, comb the lice from his matted hair and even pick the crumbs from his long, greasy beard. Ugh! She hated it!

So Alice and a fellow servant, Richard White, plotted to murder old William Wise. One morning, Richard strangled William with his own neckerchief, and Alice, just to make sure he was dead, finished him off by drowning him in his own steaming bathwater.

Then they ran—but didn't get far. They were captured, brought back to trial, found guilty and sentenced to hang. But Alice had a surprise—she told the judge she was with child. So he delayed both sentences, and everyone waited to see.

Sure enough, months later, Alice did indeed give birth to a baby boy. The infant was stripped from her arms just two weeks later, and Alice was taken to Percival Square (now Wright Square) and hanged.

This was the first public execution in the new colony of Georgia, and everyone turned out to see the spectacle. Alice didn't disappoint. She was taken to a large oak tree where she was hanged, screaming and cursing the people and trees that surrounded her until the weight of her body against the earth took her last breath.

Richard was hanged the following day—and the day after that—and the day after that. You see, his sentence was to be hanged by the neck until dead, and that's how long it took them to get the job done.

To this day, Spanish moss does not grow on the northeast corner of Wright Square. That's because Alice cursed it as she died, a curse that lingers to this very day.

Tourists are warned: "If you walk through this square late at night, don't be surprised if you see a sad, wild-eyed woman. It's only Alice looking for her lost baby. The Savannah police receive several reports every year of a hysterical woman in Wright Square who is looking for her missing child."

WASHED ASHORE

A sloop loaded with servants was forced here through the stress of weather and want of victuals, many of them were dead. Only 40 remained, as they were likewise ready to perish through misery.[3]

Alice Riley took a huge risk in 1733. She decided to embark on a dangerous voyage to an unknown fate across the Atlantic Ocean. It was not long before Alice's optimism turned into a fight for her life on the ship. On its way to Philadelphia, the sloop encountered a winter storm that decimated the passengers.[4]

Midway through the trip, she had long forgotten the hope-filled encounter with the recruiting agent who pumped her full of dreams of eventual prosperity in the New World. She and the others on board were fighting for their lives.

What stores were not lost at sea were soon depleted, and the survivors were ill and starving when they were finally rescued. By the time help arrived, only six women and thirty-four men, all young and unmarried, were still alive.

The boat limped into the cold Savannah harbor on January 10, 1734, just eleven months after the founding of the colony.[5] Even though the Georgia charter discouraged the presence of servants, especially Irish ones, Oglethorpe ignored this and took sympathy on them. He also needed their labor.

He purchased them for five pounds a head and gave them out to various widows to help with their work. He sent four to the cattle farm on Hutchinson's Island, on the north side of the river. Fellow indentured servant Richard White, who would play such a pivotal role in Alice's life in Savannah, was probably one of the four.

Alice was initially sent to the home of Richard Cannon. Cannon came over on the first ship of settlers. His wife and two of his children had died after embarking for Georgia, leaving only his son, Marmaduke, which explains why Alice ended up in Cannon's home. Alice's duties undoubtedly included caring for the boy.

HARSH CONDITIONS

Alice and her fellow servants must have felt one of two ways as a result of their terrible ordeal at sea. They either felt extremely fortunate to have been saved from death, subjects of some wonderful divine providence, or they were angry and bitter once they landed in the colony and understood the harsh, difficult landscape that lay before them.

They could have felt a mixture of both, depending on the time of day and particular menial and difficult chores they were given to perform.

Conditions were harsh when they arrived. Everyone was expected to pull their weight in forging the raw forest before them into a civilized and hospitable city.

It seemed to Alice all these people in Savannah did was work, work and more work, cutting trees and building houses and fortifications. As if working from sunup to sundown wasn't enough to eventually kill a person, there was the "seasoning" period of adjusting to the different climate.

There were also social double standards for indentured servants, particularly Irish ones. Many servants received a more severe punishment for common crimes, and there were plenty in colonial Georgia. Whereas many free persons were fined for petty crimes, such as "profaning the Sabbath," servants were frequently whipped, often receiving sixty or one hundred lashes.[6]

Irish servants were under a special suspicion in Savannah, since the colonists felt they were Roman Catholic, whether they actually were or not, and might side with the Spanish in Florida, who made no secret they wanted to expand into Georgia. To be an Irish servant in Savannah was to be a potential spy for the enemy.

Alice and Richard: The Cattle Farm

Alice Riley did not last long in Cannon's home. Whether she was difficult to deal with or Cannon simply did not need her services since most of his family had died, by early February 1734 she was sent to the trustee cattle farm across the river on Hutchinson Island. She was now in the company of fellow servant Richard White.

Every version of the Alice Riley ghost story says the pair was in love. How probable is this? Is there any evidence to support it? Just because they were both involved in the same tragic events that would seal their common fate does not mean they were lovers. Let's take a look.

They were both Irish and indentured servants who arrived on the same ship.[7] The vessels used to carry passengers like them to the American colonies were small and crowded, with approximately eighty to one hundred people on board. They more than likely knew each other before landing together on the island, either meeting on the ship or after landing in Savannah.

It is possible they fell in love before embarking on their journey.[8] They could have come from the same small village in famine-swept Ireland and

Hutchinson's Island, site of the trustee cattle farm.

been very much in love. If they were lovers, they could not marry in the New World until both completed their time as servants. But they could carry on an amorous relationship without being married.

They surely would not have been the only ones in the colony engaged in this type of behavior. The colonial records reflect numerous instances of people living in "open adultery," as Georgia officials called the practice.

And the practice was not just relegated to the poorer ranks of Savannah inhabitants, such as servants. The town's first official town recorder, Thomas Christie, "lived in open adultery with Turner's wife" in 1739 and was "guilty of other faults."[9] He was subsequently removed from his official position as a result.

A more likely scenario for Alice and Richard is they were thrown into each other's arms and hearts by the terrible circumstances they endured on the ship and the colony. The pair found solace in each other's company.

Richard could have saved Alice's life on more than one occasion during the winter storm that almost killed them. They were now working together in the same household, and things would surely be better for them.

Master William Wise

A somewhat shifty man named William Wise was their master. Wise's own story boggles the mind and reveals a good deal about his deceptive and swindling nature.

The scalawag applied to come to Savannah in June 1733 and wanted the trustees to pay his way over. The problem was he wasn't a debtor, a requirement for payment of passage to Georgia. He may have been of aristocratic stock at one time and had fallen on hard times. The Georgia Trustees president, John Percival, referred to him as "an unfortunate gentleman."[10]

Wise would provide further letters of recommendation to no avail. He took matters into his own manipulative hands since the Trustees were dragging their feet on the matter, boarding the ship *Savannah* on September 11, 1733, determined to go. On the way over, the Trustees denied his request, but it was too late. He was already bound for the city.

The former aristocrat would cause a good deal of trouble on the trip over. Many others on board complained of his behavior, especially when it was discovered the young woman he claimed was his daughter turned out to be a prostitute.

He assumed the position of the master of the cattle farm on the island after he landed. The trip over and the demands of his position caused him to become ill, only adding fuel to his corrupted and manipulative personality. He was apparently a very vain man, taking pride in his long, flowing hair. However, like Samson before, his proud locks would end up contributing to his demise.

What a tortuous physical and mental state Alice and Richard must have been in! They were surely wounded, perhaps beyond repair, experiencing a lifetime of poverty in their native land only to board a ship and come so close to death.

Were their minds warped, too? Had they gone mad, already experiencing enough tragedy in a lifetime, with only more to come?

Their collective traumas would push them over the edge of despair to perform an act they would both regret.

Murder Most Foul

"The unfortunate Mr. Wise… The manner of his murder was thus…."[11]

Monday, March 1, 1734, probably started out like any other day at the cattle farm. Alice and Richard would have received their marching orders, laid down by Wise: "Take care of me before you do anything else!"

Alice had the humiliating job of bathing the sick man, while Richard was told to comb Wise's long, greasy hair. But this day the two snapped. They'd had enough—of the disastrous trip over, Savannah and especially their demanding and humiliating master, William Wise.

Alice coolly responded as usual to Wise's demand, bringing a pail of hot water for his ritual bath and hair cleaning. William Wise was largely confined to his bed by this time.

Instead of performing their usual demeaning tasks of cleaning and grooming the sick man, they had something else up their sleeves. Richard White concocted a dastardly and dangerous scheme to free the two of them from Wise's abusive clutches and liberate them from their despairing situation. Wise was oblivious to their plan.

As the two approached the prostrate, sickly man, Richard shot a quick glance toward Alice, nodded and then quickly and coldly carried out the execution. He snatched Wise's handkerchief and wrapped it tightly around his neck. Richard then began strangling Wise with all his might, focusing every ounce of fury onto Wise with a single intent—to murder him!

Alice pitched in for the kill, too. She grabbed Wise by his long, lustrous locks after White strangled him and plunged his face into the pail of water to finish him off. A few bubbles came up from the bottom of the pail. Alice plunged him deeper, her heart madly racing. She was screaming with fury inside, yet quiet as a mouse.

Wise's body went limp as the last pocket of air slowly ascended to the top of the water and burst.[12]

Wise was unable to fend them off. It was two against a weak and sickened man. William had no chance. He was dead.

Alice and Richard were now on the lam and surely ran for their lives to escape the penalty for the crime. They committed the first murder in the colony just over a year after the city was settled, and they knew the authorities would be hot on their trail when Wise was discovered. To make matters worse, they not only murdered Wise but also robbed him of what valuables they could carry along.[13]

They were apparently quickly captured and brought into town to face the consequences of their murderous actions.

A grand jury was convened to discover facts and found enough evidence against the two. They were taken to trial on May 11, 1734. Alice and Richard were found guilty of murder by the twelve-man jury and sentenced to hang. Alice's former, but brief, master, Richard Cannon, was on that jury.

Alice, however, told them she was pregnant. The chief magistrate, Thomas Causton, stayed her execution until the baby was born. This was done out of respect for the innocence of the expected child.

Richard and Alice were housed in separate jails, as was customary for men and women. Since she was convicted of murder, Alice would not have received any special attention due to her being pregnant. Like Richard, she spent her time in an "uncomfortable and primitive building that featured dirt floors, little or no lighting or ventilation, no heat, and meager provisions."[14]

Now the two were in a real mess. One thing was certain: William Wise was dead. Alice and Richard were facing the gallows in a few months.

PUNISHMENT

"The woman was hanged yesterday, and denied committing the murder of Wise..."[15]

Alice gave birth to a boy on December 21, 1734. She named him James, perhaps after Oglethorpe, in the frantic hope of reaping sympathy from him to reduce her sentence and allow her to care for her child.

But Oglethorpe was not in Savannah. He had left for England with an Indian delegation in March, and the Savannah authorities, led by Thomas Causton, were doling out Georgia justice, not Oglethorpe.

They came for her on January 19, 1735, three weeks after James was born. The gallows had been built and there was no further recourse than to carry out justice.[16]

Alice begged for her life as they dragged her from the jail, saying, "I didn't do it! It wasn't me! You know I didn't kill him! Richard did it. He forced me to do it! Please, please, let me go! It wasn't me! *It wasn't me!*"

She was already weak from childbirth and her ordeal in jail. They brought a horse-drawn cart to the jail door and put her in it.

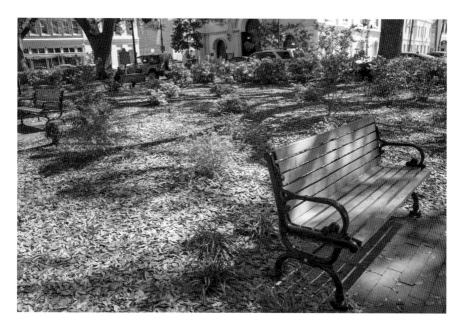

Site where Alice and Richard were hanged.

It was a short ride to the gallows, since the jail was just yards away. A large assembly of townspeople were watching the condemned woman as they wheeled her cart around the square.

British custom, carried out in Savannah, was to have the condemned placed in a cart, along with loved ones, if possible, and a minister to comfort them before their death.

The town minister, the Reverend Samuel Quincy,[17] began reading from Psalm 23: "Yea, though I walk through the valley of the shadow of death…" It was becoming all too real to Alice. She truly was walking through the valley of the *shadow of death*.

Alice's cart pulled up beside the gallows. Everyone exited the cart except the condemned woman. The crowd—men, women and children—focused their eyes intently on Alice's every move. There was a circus atmosphere in the square.

Her frantic cries became more desperate as she begged them to spare her life, coupled with sobs and harsh weeping: "I'm telling you all, I did not kill him! Oh please, please listen to me!" She was now completely alone in the world with no one to save her.

"My baby! Where is *my baby?*" Alice desperately scanned the crowd in vain looking her baby boy, James.

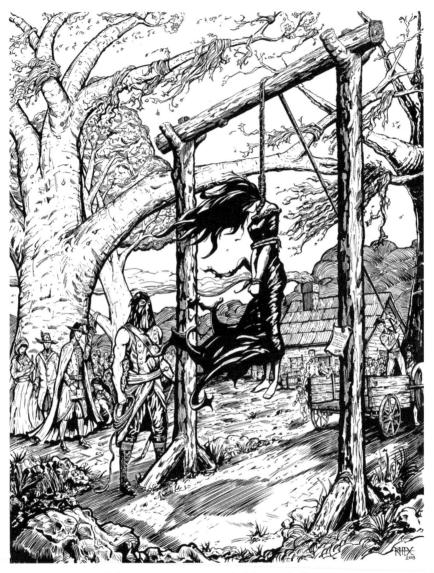

The Hanging of Alice Riley
Wright Square, Savannah, Georgia, January 19, 1735
Illustrated by George R. Hicks

The time for justice had finally arrived. The hangman lowered the heavy rope around her neck just below her left ear and tightened it.[18] Quincy continued reading, "Thy rod and thy staff they comfort me…"

Dark clouds rolled in; the sun was shielded from view. A dank, ominous darkness descended on the crowd in the square. Malevolent spirits could be felt in the air they all breathed. Approaching death could be seen and felt by all.

The time was upon her. Alice was now begging for mercy and screaming curses with the same breath: "I am innocent! Please! Please stop this madness!" Some in the crowd began to jeer as the executioner readied for the final act. "Hang her! Now! She's a murderer and an Irish wench!"

By now, every fabric of civility was drained from Alice. One last emotional rage came up within her, and she yelled indiscriminately into the void, "*Teigh trasna ort fein!*"[19] a curse that roughly translates as "Go across yourself!"

The hangman gave the horse a hard slap on the rear to move him away from the gallows. Quincy, aware of the drama unfolding before him but unable to stop it, kept reading: "Yea, though I walk through the valley of the shadow of death, I will fear no evil…"

Alice was almost limp from exhaustion. Every part of her body and mind was numb. All she could picture in her mind was the baby she was leaving behind. She almost passed out.

The horse wouldn't move. It sensed something strange and uncanny happening. The hangman gave yet another furious slap on the rear. Causton moved in to help move the horse, pulling on the reins. The beast reared its head and then slowly walked away.

Alice's body was dragged off the cart, dropping to its end. She was plunged from this world to the next, her arms and legs violently convulsing as she instinctively tried to breathe. Within a few seconds, her face became mottled and blue, her tongue black and protruding.

Finally, she hung motionless, like an abandoned marionette doll hanging on the end of a rope of colonial Georgia justice.

Executing a person by suspending them between heaven and earth on a rope tied to a scaffold was not a pleasant thing to watch or carry out. Sometimes the procedure itself was botched. To make matters worse, Alice, the first person hanged in Georgia, was a woman.

Family members sometimes would try to help the condemned by hanging on to their legs to make them die more quickly, but Alice was alone in the New World, especially in her death. Who would have helped her or even cared?

DEAD MAN WALKING

Richard was next to be hanged but somehow managed to escape. Legend has it he tried to make his way out of the colony by traveling south out of the city limits, through the woods and swamp toward the backwater route to freedom.[20]

He was spotted the day after Alice's execution, January 20, by a group of men clearing trees on a plot of land—Edward Jenkins, brothers Henry and William Parker and a couple of their servants. Jenkins and the Parkers were somewhat influential early settlers, at one point serving as bailiffs in the city. These men brought Richard White to justice.[21]

One of the servants spotted Richard from a distance as they were working and shouted, "Yonder goes a man very fast!" Jenkins recognized him as the escaped convict. He told the men to take their tools, two hooks and an ax, and apprehend him.

They took off after him and were given instructions to kill him on the spot if he resisted.

Jenkins shouted Richard's name when they drew close and told him it was useless to run or resist. Richard was shocked when he saw the men chasing him. He thought he had made his way to freedom.

He ran as fast as he could through the swamp, but the men chased him down and surrounded him with weapons raised.

Richard fell on his back against a log and started begging for his life. Jenkins grabbed him by one side of his collar, Henry Parker on the other and they dragged him back to town. The men roughed him up a bit and started questioning him as they made their way back.

Jenkins wanted to know where he was headed. White told them he was looking for a "house" outside of town to get provisions but couldn't find it. He also said he was looking for "the woman" and said he'd left her nearby.

Richard was begging for his life the whole time he was being dragged into town. He pleaded with the men to let him go. Jenkins told him if they left him in the woods, he would surely perish. White quickly retorted: "I would joyfully perish in the woods rather than die upon the gallows!"

Jenkins told White if he told the men all he knew of any other troublesome Irish servants, his life might be spared.

Richard "earnestly declared before God" and spilled his guts. He told them certain Irish servants were plotting to break into the community store and steal supplies, and if anyone reported their plan they would kill them and do the same to "many others" who told of their plot. White then continued to beg for his life but told the men no more.

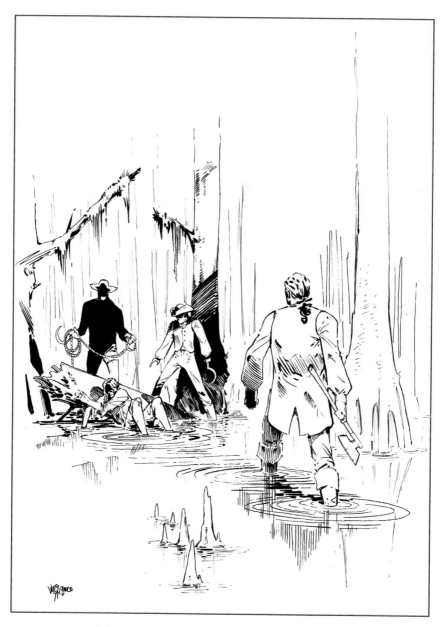

The Capture of Richard White

Savannah, Georgia, January 20, 1735

Illustrated by Wes St. Claire

Jenkins ends his narrative of the capture by bluntly reporting: "So we carried him into town and he was immediately taken to the gallows."

The rope was still warm from the execution of Alice the day before. Richard met his death in the same manner as his female accomplice, protesting his innocence to the bitter end.

Oglethorpe and the trustees were informed Alice and Richard each died "a Roman." In the minds of those who carried out justice, they had rid themselves of two murderous Roman Catholic potential spies, not to mention cold-blooded murderers.

Jenkins and the Parkers were given a reward of fifty pounds put up by the Georgia Trustees for the capture of White. This was no small sum in 1735, amounting to approximately $15,000 in today's currency.

The murder greatly shocked the Trustees who had devised, funded, overseen and carried out the founding of the Georgia colony. Up to this point, they held a very idealistic perspective of the colony as a potential paradise for disadvantaged people.

But they were brought down to some semblance of reality as to the kind of people, at least two, who were in their colony. They wrote they "were very sorry there are any people in the colony wicked enough to do such an action."[22]

Enduring Mysteries

Tour guides today tell a romantic account of this terrible episode, implying Richard and Alice were lovers who murdered Wise to obtain their freedom. Indeed, many aspects of the legend are true.

According to the civil authorities in Savannah in 1734, William Wise was found murdered in his home, and two of his indentured servants paid for his life with their own. But many questions remain unanswered, and the possible answers are as fascinating as any legend.

How long did it take for Richard and Alice to be captured? Was it a few hours, a few days, a few weeks? Where would they have hidden?

There is nothing in the reports that indicates they were on the lam for a long time. The reports also do not indicate they were apprehended quickly, either. Everyone who studies the murder assumes they were apprehended shortly after the crime was committed. Many of the details are left out, and the reports were written after the fact of capture and hanging.

Why did it take so long for Alice and Richard to stand trial? Wise was murdered on March 1, 1734, according to Thomas Christie's report. The couple was not convicted until May 11. In those days, people were usually tried for their crimes shortly after they were committed. Jails back then were not able to keep prisoners for a long period of time. White escaped, as an example.

And what of Alice's baby, James? If he was conceived while she was imprisoned, who was the father? Unless she carried the child longer than the normal length, which is doubtful given the meager nutritional conditions in the early colony, the child couldn't have been conceived before Wise was murdered.

Alice and Richard would have been housed in separate jails, and unless the dates are wrong, Richard could not have been the father. So who was? A jailer? Some other man with whom she was romantically involved? Or was Alice raped? This is a very real possibility.

Many of the misconceptions about Alice and Richard's relationship stem from a 1959 *Savannah Morning News Magazine* article by Lillian Bragg, entitled, "The Woman Savannah Hanged." Bragg embellished her tale by speculating the two were lovers who wanted to escape Wise and the city to get married. She says the pair were from the same Irish village and fell in love before they made the trip across the Atlantic Ocean. They were headed for Charleston, so she wrote.

In truth, we'll never know whether Alice and Richard were romantically linked. Oglethorpe indicates he sent four of the forty over to Hutchinson's Island. Alice and Richard are linked romantically in Bragg's account because they are the only two punished for the murder.

Some people speculate William Wise was the father, but that seems unlikely given his sickly condition. The accounts say he was bedridden and very ill during their stay.

Who attended to Alice during her internment and pregnancy? Someone surely must have. How difficult it must have been to know her child was going to be born in this hard, foreign land, while the only future Alice faced was death on the gallows.

Did Alice pray for leniency from "Father Oglethorpe," as many of the early colonists called him? He certainly was known to be a kind-hearted man at times. Not long after the colonists arrived, he prevented a servant girl accused of loose behavior from receiving forty lashes and simply sent her back to England.

Why did Alice and Richard murder William? How abusive could he have been toward them? Added to this is the fact they only had to endure

their situation for three or four years before they would win their own personal freedom.

If Wise was indeed as sick as reported, then surely it must have occurred to them he might die soon, like many of the others in Savannah. So why kill him? Was their primary intention to rob him of his valuables, and then decide at the last minute it was better to rob *and* kill him, since the penalty for both crimes could end in death by hanging?

Wise's effects brought twenty pounds sterling when they were sold. Writing in his report of the murder, Thomas Christie says of his possessions, "No doubt a great many were stolen by that villain who murdered him, whom we never could find."[23]

So what happened to the loot? Did White and Riley pawn it off to local residents undercover? Did some Indians or Indian traders do business with these two "devils," Riley and White?

White did tell Jenkins he was looking for a house in the woods. Was this a Creek Indian house? Did White have other associates?

Jenkins's account of the capture makes for high drama. He wrote that White was looking for a woman in the woods. What woman? He probably wasn't looking for Riley, since he must have known she had already been hanged.

White was intensely questioned about other Irish "malcontents" after his capture. Could Riley and White have been framed for Wise's murder because they were Irish and suspected of being Roman Catholic, hence sympathetic to the Spanish forces in Florida? Were they victims, puppets, in a larger scenario of fear and vulnerability?

Not only were conditions harsh in colonial Georgia, but its residents also lived in a climate of fear—fear of hostile Indians and fear of war with the Spanish. They were particularly paranoid about the Spanish in Florida, certain that attack was on the horizon. When war with the Spanish did break out in 1739, many residents left town for fear of attack.

Rather than welcome the newcomers and the addition to the labor force, the colonists viewed the new arrivals with suspicion. The forty servants were seen by many as convicts and dangerous to the colony.

Could Riley and White have been victims of bigotry?

Alice Riley may have acted out of fear of Richard White and was drawn into the murder because she was ordered to at the risk of her life. If Richard White could rob and kill William Wise, he could surely kill her as well. Christie reports Alice acted under the "direction and influence" of White.

Perhaps White was not her lover but a cold-hearted man who wanted to get out of Savannah as fast as he could. Alice was drawn into the mess simply because she was in the same household with Richard.

Or, finally, they indeed could have been lovers and eliminated what they perceived to be the major roadblock to their desired blissful life—William Wise. The added attraction would have been his money.

Contemporary Ghost Appearances

Various people in two locations—Hutchinson's Island and Wright Square—have spotted the ghosts of Alice Riley and Richard White.

One person claimed to see a man and woman huddled together walking in a rainstorm on a road on the small island.[24] He reported they were dressed in eighteenth-century clothes, and he thought they were extras in a period film being shot in Savannah. When he looked at them again in his rearview mirror, they had vanished.

The late Ted Lewis, a former Savannah ghost tour trolley driver and master storyteller, often claimed to have encountered Alice Riley wandering in Wright Square when he was a child. Lewis lived in Atlanta but spent summers with an aunt in Savannah, where he worked on his uncle's boat.

One night, he and his young cousins, after a hard day of work, headed home by taking a shortcut through Wright Square. "We saw a white woman wearing a long, tattered dress, standing in the square," Lewis said years later.

"Her face was very plain, almost ugly. She wore a cap, and under it, her hair was limp, stringy and greasy. When we thought about it later, we realized we couldn't see her feet. They just weren't there!

"She kept saying, 'Where's my baby? Where's my baby?' and holding out her arms. We told her we didn't know where her baby was, and ran as fast as we could for home."

For a time, the three boys kept the whole incident a secret, but it worried them. "Here we were, three black boys, and this was a white woman," Ted said. "We were afraid someone would think we took her baby."

After weeks of waiting for the police to break down the front door, Ted finally told his aunt what had happened. To his amazement, she laughed and said with a smile, "Don't worry, honey. That woman has been looking for that baby for more than two hundred years now."

Do their spirits remain on the land where they once lived and, ultimately, met their tragic end?

The search for the ghosts of Alice Riley and Richard White still goes on.

CHAPTER 2
SLEDGEHAMMER

RENE RHONDOLIA

Giant—a legendary humanlike being of great stature and strength.[25]

*I*t was a dark night in Foley's Alley, one of Savannah's poorest neighborhoods in the early 1800s. Mary O'Hara was hungry; the gnawing in her stomach was keeping her from sleep. She slipped from the loft where she slept with her many brothers and sisters and went in search of food.

"You selfish brat!" yelled a voice from the darkness. The little girl's mother quickly came and grabbed her by the neck of her nightdress. Mary's siblings screamed out of fear.

The woman pushed the girl to the front door of the hovel and opened it wide, saying, "Maybe this will teach you not to steal food in the middle of the night, you little thief!"

The mother pushed the child outside, pulled the door shut and barred it. Stumbling back to her pallet, drunk, she soon fell fast asleep, already forgetting the encounter with her daughter.

But Mary cried as she wandered from house to house, hoping to find someone awake to let her inside. Her hunger, so acute just moments before, was now replaced by a deep dread of the untold horrors of the dark.

As Mary huddled piteously outside a neighbor's door, already afraid, her fear turned to horror as a huge shape unfolded in front of her eyes. The little girl started to shake and turned toward the door, hiding her eyes. She desperately knocked in hopes of finding someone who would open the door and let her in. She was still outside, despite her knocking.

Meanwhile, the sound of heavy footsteps came from behind, and the hot breath of a predator fell on Mary's neck. She wanted to run, but her feet seemed rooted to the ground. Her knocks on the door fell silent.

Finally, Mary's brain roared back to the menacing presence behind her as the adrenaline coursed through her veins. She darted through the bushes and ran as fast as she could, soon realizing to her horror that whatever was chasing her was still within reach.

Then it was too late. Heavy, strong hands grabbed her by her slender neck, and her feet were soon running on thin air. The creature's hands gave a sudden, violent twist, snapping her slender neck.

The child was dead.

Her lifeless body dangling from his massive hands, the murderer proceeded to Warren Square. At one of the massive oaks lining the square, he hung his latest trophy on the branches along with his earlier prey—the rats, squirrels and rabbits that now hung from the limbs like macabre fruit.

The horror of this discovery echoed across Savannah's east side. A mob-like group of concerned citizens soon formed and made their way to the hovel occupied by the Rhondolia family.

The yelling, screaming and banging on the front door brought an ashen, shaken couple from the depths of the house. "Please, please, stop yelling! What do you want?" the man cried.

"We want the monster! We want your son!" came the reply. "We want Rene!"

"Why?" the wife demanded.

"Because he's a murderer!" they yelled.

"Why can't you people leave him alone? He's just a boy, for god's sake!"

The Rhondolias were ignorant of their child's inclinations.

"He has the hands of a murderer!" a man from the mob yelled. "Mary O'Hara is dead! She's hanging from an oak tree! Rene did it!"

"But it couldn't have been Rene. It couldn't have been!" Mrs. Rhondolia said, sobbing. Her husband, silent in the face of the barrage before him, wrapped his arms around her for protection. He, too, was afraid.

"He was here all night. Oh please, please, do not take our son. It wasn't Rene!" Mrs. Rhondolia cried.

From the doorway stepped a large figure, a giant of a human being, more than seven feet tall and still a boy. His hands were as big as hams. He stared at the mob with no expression, his mouth slack and drooling, his eyes empty and unfocused. The crowd shrank back before him.

He murmured something unintelligible and ran to his mother, crying. Taken aback by the sight of the sniveling boy-giant, the mob fell silent.

The leader finally said, "Maybe we were wrong. It might not be your boy, but someone has been killing small animals and now a little girl."

After some argument, it was agreed that volunteer guards would be posted at the Rhondolias' house every day and night to make sure Rene did not roam. Her grieving family buried poor little Mary O'Hara, and the city fell into an uneasy state of waiting.

A large fire started soon after Mary's death on the west side of town at Boone's Livery Stable and spread throughout the city. Everyone was called to fight it, including Rene's guards.

When they returned late that night, exhausted and smelling of smoke, the guards discovered Rene's room was empty. The body of another child was discovered just two blocks away.

As for Rene, he savored his moments of freedom. Despite his mental limitations, he was all too aware that he was different from everyone else, and on this night, he reveled in that difference.

Going at an easy lope, Rene was soon outside the town limits, headed toward the countryside to an area he had never been. As strong as he was large, he scooped up small animals as he ran, dispatching them with quick twists of the neck.

When he spotted a small herd of cattle, Rene stopped in awe. This was the first time he had seen such animals, and he desperately wanted another trophy for his collection.

As Rene ran toward the cattle, he was startled by a sudden, loud cry: "There he is! There's the monster of Foley's Alley! Catch him!"

The mob encircled Rene, using pitchforks to jab him. He began to keen in a high, garbled voice, but the men were not moved.

The boy-giant tried to fight his way to freedom, but there were too many arms holding him down. They continued poking at him with their weapons, making sharp, quick cuts in his body. He was bleeding and squealing as they began their torture.

He was wrestled to the ground and bound with rope, placed on an ox-drawn wagon and hauled deeper into the woods.

The procession halted at the massive oak tree. A thick rope was thrown high into the tree, and one end was looped and tied around Rene's neck into the hangman's loop.

Unused to this kind of treatment, Rene fought with all his might. But it was no use. Fifteen men pulled on the rope to hoist him into the air that night.

Dying by hanging isn't an easy way to go, and Rene's neck was thick and strong. It took him a long, long time to die, his mind never grasping what was happening to him, why he was being treated so violently. His limbs were swinging furiously as he hung suspended above the ground.

The body stopped twitching after a few minutes. The distorted face, now purple and blue, eyes and tongue distorted in fear after the desperate battle for air, seemed to relax.

The men finally let go of the rope, and he fell to the ground with a thud. Once again, they heaved him onto the cart, which was driven even farther into the woods, to a swamp where Rene's body was thrown into the water.

No prayers were said. No marker was erected. The men finished the job and returned home as quickly as their feet could carry them. They made an unspoken pact among themselves to keep silent about what they had done.

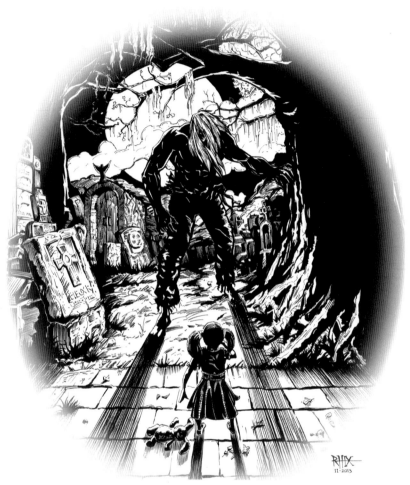

Rene Rhondolia

Colonial Park Cemetery, Savannah, Georgia, Fall of 1820

Illustrated by George R. Hicks

The nightmare of murders that had plagued the city, however, would not end. Just weeks after the vigilante execution, a woman's body turned up in Christ Church Burying Ground (Colonial Park Cemetery), her neck snapped like the previous victims.

Two children disappeared from their Foley's Alley homes, never to be heard from again. Murmurs began, implying that the ghost of Rene Rhondolia killed them—the Boy Giant of Foley's Alley, who is said to be wandering the back alleys of Savannah and Colonial Park Cemetery, even today.

A Tall Tale?

You would not wish to meet Rene Rhondolia in the dark, especially if you were a small animal or a young girl. Most adults knew better than to approach him and kept their distance.

Rene Rhondolia was different. He had the physical size of a giant, the strength of three men and the mind of a simpleton, all crammed into a massive body that exceeded his age. He was a freak, pure and simple.

He was one imposing figure at more than seven feet tall and five hundred pounds. And if his sheer size wasn't enough to evoke feelings of vulnerability in normal-sized people, his mental constitution lent itself to eruptive displays of destructive curiosity. Rene Rhondolia was not only a freak of nature; he was also a dangerous freak.

But did Rene Rhondolia really terrorize Savannah residents during the early nineteenth century? Does he exist anywhere other than the imaginary world of a Savannah ghost story?

The short answer to the first question is no. Despite assertions that historical documentation verifies the existence of a "Rene Rhondolia" in Savannah in the early nineteenth century, no such documents seem to exist. The answer to the second question is not so easily answered.

Let us explore this fascinating ghost story in more depth.

Variations on a Ghost Legend

The Rene legend takes on different forms with sometimes widely varying elements, like all mythical tales. Some of the Rene stories locate his family near Colonial Park Cemetery, or "Rene's Playground," while others place

Warren Square, where Rene was hanged in one version of the story.

Rene's spiked fence, along the back wall of Colonial Park Cemetery.

them in what was called "Foley's Alley," a poor, predominately Irish section of town.

He appears on the scene sometime between the late eighteenth and early nineteenth centuries. He is referred to as a "boy-giant" whose size was manifest during a difficult delivery. His mother's pelvis had to be broken just to accommodate his huge infant body—close to sixteen pounds and measuring nearly twenty-five inches in length!

Rene supposedly weighed nearly five hundred pounds at the mere age of twelve and stood over seven feet tall. In some versions, his mother died during labor. He descended from French Huguenots, as his family name indicates, and he could speak only broken English. His mother's name was Maria.

Rene's mental makeup was also different from others. He is referred to as possessing a "simple mind." He would catch small animals and play with them and would end up killing them because of his limited mental capacity and immense strength. He would also be found fondling animals he had already killed and had a fondness for hanging his victims on the limbs of trees as prizes.

Because of Rene's strangeness in both size and psychology, and out of fear, the residents of Savannah went to his home and asked his parents to contain him. The father reluctantly agreed to lock the boy inside while he went to work.

One version of the story has his father constructing a brick wall outside the house with iron bars to keep the boy from wandering at night.

In 1820, already reeling from the Great Fire that destroyed much of the city, the body of a young child, usually said to be a little girl in the story's telling, was found in Warren Square. She had been strangled to death.

In response, the outraged residents of Foley's Alley directed their rage at Rene, blaming him for the murder. They dragged him to Warren Square and hanged him from an oak tree on the southwest corner. It took several men to drag him to his execution because of his size and a long time to die, since his neck was not broken after being hanged.

The child killings, however, did not end with the death of Rene. They continued into 1821 with more discovered bodies.

The deaths of the children are attributed to Rene's ghost, and one Savannah ghost book author adds this to the legend: "Could he have come back from the grave and continued to kill? Or did they put an innocent person to death?"[26]

THE MYTH GETS BIGGER

The Rene Rhondolia ghost story is subject to more variations than the usual ghost tale because it is composed of mythic elements. The fact that no such unusual person or family can be historically documented lends support for this practice. In addition, the main character of the tale, Rene, is composed of larger-than-life mythic qualities, not unlike other mythic characters in stories.

In a way, the Rene Rhondolia story is Savannah's own version of a Greek myth. That is to say, like the half-human, half-beast creatures terrorizing human beings in these myths, Rene appears to be more than a giant of a boy. He takes on beastly qualities, as well.

As mentioned above, different versions of the Rene ghost story exist depending on who is telling it. Since Rene cannot be documented, the story exceeds any constraining historical parameters that might otherwise limit it. Websites and paranormal programs, as well as Savannah ghost story guides, can have a field day with the story.

The Rene legend was featured on the TV program *The Scariest Places on Earth*, hosted by none other than Linda Blair, of *The Exorcist* fame.[27] The episode is introduced with a gravelly demonic female voice, reminiscent of Blair's character, Regan: "The shocking story of Rene, known as the Frankenstein of Savannah, began in the 1700s."

Those interviewed on the program assert Rene's historical presence was verified by local newspapers as being "seven foot, four, being about 390 pounds." The date and year of the newspaper, however, is not given. One person gives details, stating the boy-giant "was violent and would chase neighborhood kids around the block."

In this episode, he is responsible for the death of two sisters in Colonial Park Cemetery and targeted by a mob that hauls him not to Warren Square but to the Savannah riverfront, where he is lynched.

A *CNN* article about haunted Savannah also mentions Colonial Park as being "Rene's Playground," citing local sources.[28] More details of Rene's mythical life emerge. In this variation of the story (what *is* the real Rene Rondolia story?), Rene is targeted by some of Savannah's leading civic officials as a monstrous spectacle, only to be paraded before visiting dignitaries near River Street. He is housed in a cage in this version, appropriate for a murderous giant, no less.

Variations on his name also crop up. He is referred to as "Rene Rhondolia," "Rene Rhondolier" and even a Jewish twist is added: "Rene

Ashe Rhondolier" (or Rene Rhondolia Ashe). He is also depicted as being covered with hair from head to toe, and some variations state he was an orphan. A portrait is shown depicting him as a creature akin to the Wolfman.

Literary influences for the myth are said to include Shelly's *Frankenstein* and Steinbeck's *Of Mice and Men* (the character Lenny). Some even go so far to assert the Rene story influenced Shelly's Frankenstein character.

Finally, the story is viewed as a campfire story used to scare children. From this common perspective, the story is similar to other folktales and scary stories used to teach children to be wary of strangers, especially large hulking ones who might inflict harm.[29]

It is a more dramatic and sinister way of telling children not to take candy from a stranger.

Perhaps the best reason the Rene Rhondolia ghost legend is told so many different ways beyond the usual variations on a ghost story is precisely because it is such a rich and primal story of fear—a fear not only appropriate for small boys and girls. The tale keeps being told in different ways because it speaks directly to the human reality of being terrorized by authentic malignant and evil forces, even persons.

The tale also speaks to historical realities that are present in virtually all cultures, even though Rene Rhondolia cannot be mapped on the Savannah scene in the early 1800s.

Here are a few other takes on this fascinating tale.

Interpreting "Rene"

At one interesting level, Rene Rhondolia has the characteristics of a classic "scapegoat" myth.[30] A strange and seemingly malign human appears on the scene and sticks out like a freak of nature from his fellow community members. In this case, he is a giant at twelve years of age, psychologically different, even radically strange, from his peers.

Rene is a scapegoat in the tale, since the deaths of young girls are immediately blamed on him without supporting evidence. The usual intervening police and judicial group are notably absent. No one investigates the deaths in the story; Rene's guilt is assumed.

Such myths are told to mask the human tendency to blame innocent people (usually members of a minority group, or a person who significantly stands out from the norm) of various evil actions and crimes. In such scapegoat tales, monstrous attributes are projected onto the designated perpetrator or perpetrators, who are usually lynched or killed by a mob in such myths.

The story even takes on anti-Semitic characteristics due to the attachment of a Jewish name to Rene.

The function of scapegoat myths are to conceal the inherent violence in human communities by righteously, one might say, or legitimately eradicating the source of the human terror—a monster.

This "larger than life" tale illustrates a nasty reality of groups and culture, especially pre-modern cultures: a tendency to resort to collective violence to rid itself of perceived threatening persons or groups. In short, the tale reflects an actual tendency among people in nineteenth-century Savannah: lynching as a method of ridding the community of unwanted elements.

Peace is restored to the community once the monster is removed in such myths, until the time arrives for another monster to perform the same function.

Finally, the myth also seems to have affinities with a popular story in the Gospel of Mark, the story of the demonic "Legion" who lived among the tombs.

The story goes like this:

> When Jesus came out of the boat, a man with an unclean spirit immediately raced as fast as he could from the tombs to meet him. This man was living among the tombs, and no one was able to bind him anymore, not even with a chain, for he had often been bound with fetters and handcuffs, but the handcuffs were continuously torn apart by him and the fetters broken, and no one was able to subdue him. Night and day he was continually crying out among the tombs and among the mountains and beating himself with stones. (Mark: 5:2–5)[31]

As human freaks, both Rene and the man named "Legion" are relegated to the walls of a cemetery to live out their tortured lives. Constraining objects bind both—Rene the brick wall with spikes and Legion the chains. Furthermore, neither character can be completely restrained by the makeshift prisons imposed by the community.

Unlike Rene, however, Legion has his demons exorcised and returns to live a normal life among his family and friends. Rene, conversely, meets a more sinister end.

CONCLUSION

This rich ghost story continues to fascinate people from all walks of life, young and old, because it speaks so directly to innate fears of being devoured by an uncontrollable, larger-than-life, malignant—if unintentionally so, in this case—monstrous force. It exposes our vulnerabilities and occasional incapacity to control these real forces.

"Rene" is the child's monster under the bed or in the closet that cannot totally be outgrown. He is the monster who sometimes threatens us in real life, leaving its victims behind for all to see.

Long live Rene Rhondolia!

CHAPTER 3
SHADY CORNER

THE SORRELS AND MOLLY

We are all haunted houses.[32]

One of Savannah's most popular ghost haunts is the Sorrel-Weed house, located at 6 West Harris Street on Madison Square. The house and its ghosts attracted the attention of the Atlantic Paranormal Society (TAPS), and in 2005 the house was featured on a *Ghost Hunters* Halloween special. The episode featured a full-blown paranormal search with state-of-the-art ghost hunting equipment.

Among the evidence of a genuine haunting were glowing handprints on a basement wall that are visible only under ultraviolet light, a clothes hanger that seemed to move on its own upstairs and a startling EVP, or electronic voice phenomenon, recorded in the carriage house. That EVP is reportedly the voice of a long-dead slave who was murdered in the courtyard carriage house.[33]

The story of the man who built the house, Francis Sorrel, and his family is an interesting tale unto itself. The family story features a complex web of family violence, tragedy, intrigue, secrets, prestige and death.

The family named the mansion "Shady Corner," because at the time of its construction it was nicely surrounded by many shade trees. But the intrigue in the family's story is shady, too, to say the least.

THE GHOST LEGEND

Matilda hummed a little tune as she bustled about the house. She was happy, healthy and strong for the first time in months. The demons that had haunted her were quiet for now, and Matilda was grateful to God for the renewed purpose she felt in life.

Losing three children was very difficult, but Matilda knew she was not the only mother to suffer this fate, especially during her life in the mid-nineteenth century antebellum South. After all, she had eight children left—three of them born to her own sister, Lucinda, when she was married to Francis. She loved them as though they were her own.

She was truly lucky in so many ways, living in a fine, beautiful house with a husband so beloved and successful in the community. And Francis was good to her, standing by her side even as she screamed and pulled her hair and fell into an apathetic numbness or simply slept for days when she descended into her bouts of depression. He was always so loving, so kind.

It was Francis who suggested the upcoming party. He was so delighted at Matilda's progress that he thought it should be celebrated. And planning the party had been so much fun. Fun! When was the last time Matilda had thought about having fun?

The menu was planned, the house was cleaned inside and out and only the smallest details remained. Matilda frowned at the flowers in her hands. She was trying to create a centerpiece for the table, but the results were unsatisfactory.

Where was Molly, the new mulatto slave Francis had bought her last year as a personal attendant? Molly had such a way with flowers, knowing exactly what colors went together and which blooms would hold up until the party was over.

Matilda went in search of Molly, looking first through the house and then down into the courtyard below. She spied Francis and realized with a pang that he was a shell of the man he used to be.

Now in his sixties, he moved with his back slightly bowed, walking slowly because of knees that ached fiercely when the weather changed. And the only thing certain about Savannah weather was that it would change!

Unaware of Matilda's gaze, Francis was deep in thought as he walked in the courtyard. He had worked so long, so hard, to build a successful life in this beautiful, proud city, and at such a cost. Francis had turned his back on his one true love, his one true life, in an effort to become a wealthy man, a powerful man, someone looked up to by those around him.

And by God, he'd made it! Thanks in part to his wife's dowry and his own head for business, Francis was rich beyond his own imagining. He was a pillar of society, a shipping magnate and a leading figure in his church and in the business organizations in the community.

But it had not come without sacrifice. Francis had some deep, dark secrets, even from his wife, and he would be ruined in business and society if they were to ever be revealed. In fact, his entire family would be ruined with him.

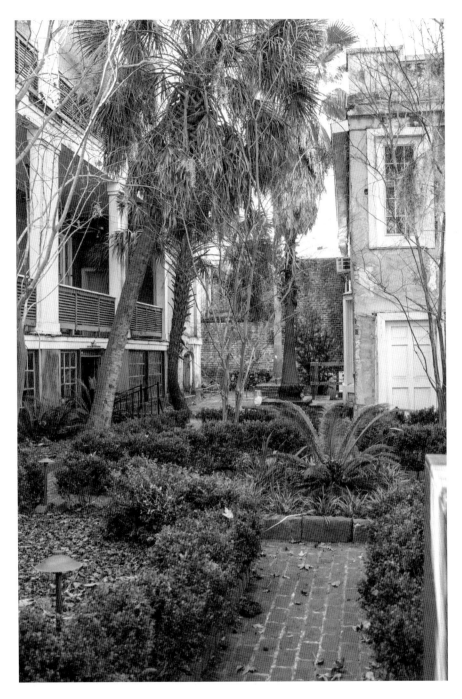

Courtyard of the Sorrel-Weed house.

Movement caught his eye. He watched as young Molly, a mixed-race slave of Haitian descent, crossed the courtyard with a heavy pitcher of water. She moved gracefully, nimbly, beautiful in her vigor and youth.

Francis felt the same stirring he felt every time he encountered the young woman. She reminded him so of the young women from his birthplace, Saint-Domingue. Lord help him, she reminded him of his beautiful cousin, Rodolphine, the one he'd loved and lost to another so long ago in Baltimore.

Her skin was a creamy brown, almost white, as was his own. Unlike Francis, Molly had been unable to escape her Negro blood, and she was enslaved—a rich man's property who could be bought and sold.

Unknown to the rest of the world, Francis was a quadroon, meaning he was one-quarter black. He had African blood in his veins and often pondered the irony that his status in life forced him to own slaves to keep up appearances—slaves who included Molly.

Francis stared at her boldly. He had rights to use this girl as he saw fit, and he made her bow to his will from the time she arrived. He told himself it was his right as her owner, but he knew deep inside he would someday pay for these sins. He might be able to hide them from Savannah society, but God saw everything.

Molly shivered. The master's dark eyes were boring into her very flesh. She could feel them.

That meant the inevitable—first, the summons to bed, no matter what duties were left undone, then the furtive coupling that had little to do with lovemaking and more to do with the man's complete ownership of her body, soul and future.

Worst of all, it was happening in Matilda's house, right under her nose, in fact. Molly loved her sweet mistress, and this betrayal, unwilling though it might be, upset her beyond words.

But there was nothing—nothing—she could do to stop it. Molly was a slave, owned by the wealthy and powerful Francis Sorrel and, as such, was expected to do exactly as she was told.

Then it came—the master's nod toward the carriage house, where Molly's room was located. She hesitantly followed him, glancing back to see if anyone was watching.

The door closed behind them. Molly undressed and climbed into the bed at the master's urging. He soon followed.

Then she heard her mistress's voice. "Molly! Molly! Where are you? I need your help. The party is happening in just a few days."

The bedroom door was flung open before they knew it, and there stood Matilda. Her look of impatience quickly turned to shock as she saw her husband in bed with her dear confidante and friend.

"No!" Matilda keened. "No, not this!" She quickly turned and fled across the courtyard, back to the house, dashing inside.

The master swore and began fumbling with his pants. "Foolish woman," he muttered. "This will set her off for months!"

Molly quickly dressed so she could go after Matilda, her only concern being what her mistress was thinking, the hurt she surely felt. But a flash of color from above caught her eyes as she opened the carriage house door to step into the courtyard.

Matilda had already gotten back into the house, climbed the stairs and was acting as if she was about to jump from the balcony just outside her bedroom. She swayed, eyes like coals in her dead-white face, her face a mask of horror and grief.

Molly heard gasps behind her as two of the housemaids came into the courtyard and saw their mistress readying to jump. More slaves soon arrived in the mistress's bedroom, and some began to plead with Matilda to step back inside.

It wasn't the first time Matilda had gone to pieces. Her life was punctuated by bouts of depression and fits of lunacy. She had buried three of the children she bore Francis, and her heart and mind seemed to fade a little more each time.

"Mother, get down from there!" Francis called as he approached the scene. "It's time for your medicine, you know. You don't want to disturb the whole house with such a fuss, do you?"

Only Matilda's eyes moved, twitching at her husband's words. Clearly exasperated, Francis called out again, "Matilda, do you want the children to see this? Get back into your room, now!"

The expression on her face never wavering, Matilda leaned forward and let go. She literally dived into the courtyard, her head crashing into the stone steps that led into the basement, causing her neck to snap. A thick pool of blood splattered from the back of her head. Matilda Moxley Sorrel was dead at age fifty-four.

A cry of horror rose from the group that gathered around the courtyard. First to reach the body was Molly, who cradled her mistress in her arms. She sobbed and entreated Matilda to stay, please stay, but as she looked at the faces around her, she saw only condemnation and anger.

"They know!" Molly thought. "They know what caused her to jump!"

The next two weeks passed in a blur. The townsfolk, titillated by the scandal, walked by in a never-ending parade to peek in the gate and stare at the spot where Matilda fell to her death.

The whole family gathered for the funeral. Molly somehow got through her many duties, although her heart felt as if it was in the ground with Matilda.

One night, grieved and exhausted, Molly crawled into bed and fell sound asleep. A sound nearby woke her. "Is someone there?" she called, listening intently, but it apparently was nothing more than her overworked imagination.

Molly rolled over and tried to go back to sleep, but suddenly strong arms grabbed and held her. She couldn't struggle; she couldn't even breathe. The room filled with sounds as more people came in.

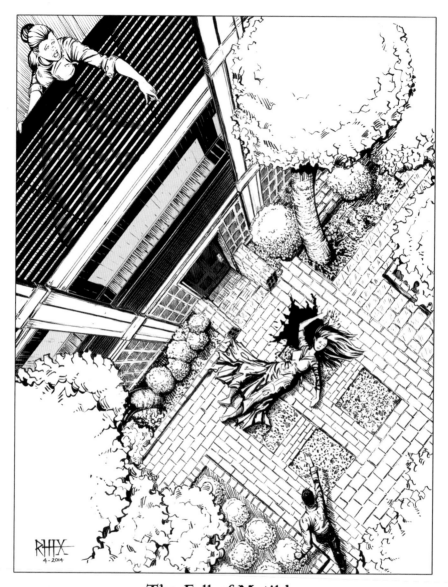

The Fall of Matilda

Savannah, Georgia, March 27, 1860

Illustrated by George R. Hicks

One of the arms loosened, and Molly filled her lungs and screamed. "Help, oh, Francis, help!" Now she was being lifted. She saw a rope in the candlelight hanging from a ceiling beam.

"Help, oh, Francis, help!" Molly screamed again. And then the crowd parted, and there stood the master, staring at Molly with those hard, dark eyes, their intent all too clear.

The rope was now fastened into a noose. "Oh my God!" Molly moaned. "Oh my God!"

But not even God heard her frantic pleas. Molly was lifted up, her head placed in the noose and then she was dangling, her neck filled with fire. She began to choke, no longer able to scream, until finally, finally, it was over.

Molly drifted upward, and for the first time in her life, she was free.

FRANCIS SORREL

Born in Saint-Domingue in what is now Haiti, Francis Sorrel was supposed to have a life of luxury. His father was Antoine Francois Sorrel des Rivieres, an engineer, French military officer and sugar plantation owner.[34]

Antoine's second wife, the beautiful Eugenie de Sutre, was a *gens de couleur libre*, or free mulatto.[35] She and other mulattos shared equal rights with whites compared to her fellow Haitians, the slaves. Eugenie, in fact, came from a wealthy plantation family.

Eugenie died before her son, then known as Francois, was six months old. The slave rebellion began in 1791, eventually culminating in the overthrowing of the white plantation owners and the outlawing of slavery.

Antoine left Saint-Domingue as a result of the ensuing bloodshed and fled to Louisiana to live with family members. He apparently abandoned Francois who, as a young teen, was forced to fend for himself. The boy never saw his father again, although they would correspond a few times in later years.

He was invited into a partnership with Richard Henry Douglass from Baltimore as a partner in the firm, Douglass-Sorrel. He came to Savannah in 1812 to manage the firm's southern headquarters.

Francois chose to conceal his African heritage, his identity as a mulatto. The racial lines in America were not the same as they were in the Caribbean island, and any hint that he was part-black would have ruined his chances for success and might even have endangered his freedom and life.

Francis spoke only French when he arrived in America. He stayed in a boardinghouse run by Madame Anne Laval. She was his mother's sister. She had a daughter, Rodolphine, who was slightly older than Francis, but that didn't stop him from falling in love with her.

Although Francis was said to have used his own money to better Rodolphine's life, she married a naval officer instead who was considerably older than her. It broke Francis's heart.

Francois changed his name to Francis Sorrel and learned to speak English, thoroughly adopting the cultural manners of Americans. He never spoke about his parents again, according to his daughter, Aminta, and would become extremely angry when questioned about his life in Saint-Domingue, refusing to discuss it.

His decision to live as a white man was successful. He was welcomed into upper-class society, even marrying into the slaveholding Douglass and Moxley families of Virginia.

Francis was able to keep his secret so well from his family throughout his life that they perhaps never realized they came from African heritage. According to family lore, some of Sorrel's children became members of the Ku Klux Klan after the Civil War.[36]

After successfully running the Douglass partnership in Savannah, Francis started his own shipping company, importing coffee, sugar, oats, whiskey, wine and beef. He became lauded as a pillar of the community as his wealth and success grew.

One of the many prestigious positions Francis held included chairman of the Board of Trustees of the Independent Presbyterian Church, which he held for thirty years. He helped found and was a patron of the Savannah Poor House and Hospital.

He also held important positions associated with the shipping industry, becoming Portuguese Vice Consul for Georgia as early as 1816. He became a U.S. citizen in 1824.

He established a waterline along the wharfs of the Savannah River and became an extremely successful importer. Francis also established a home life.

The Sorrels lived in a Greek-Revival mansion that Francis had built on the northwest corner of Madison Square. It was designed by one of the nation's leading architects, Charles Cluskey, who also designed the old governor's mansion in Milledgeville and worked on the U.S. Capitol.

As with many buildings in the historic district, the mansion was built on a bloody Revolutionary War battlefield, site of the Siege of Savannah in October 1779. In fact, workers reportedly found bodies of soldiers who were buried where they'd fallen in the heat of battle.

Construction began in 1836 and ended in 1840. The house features formal living and dining rooms and a parlor on the first floor and spacious bedrooms on the second, with a large, brick-lined basement beneath the house.

The Sorrels were known for their lavish parties and celebrations with all of Savannah's most prominent people. Both General William T. Sherman of the Union army and General Robert E. Lee of the Confederate army are said to have visited the Sorrels before and during the Civil War.

In 1822, Francis married his first wife, Lucinda Ireland Moxley, the daughter of a business partner. She was twelve years his junior. They had three children before she died of yellow fever in 1827.

Lucinda's sister, younger by one year, Matilda Ann Douglass Moxley, came to help Francis with the children, and the couple wed in 1829. They had eight children together, although only five would live to adulthood. One of them, Gilbert Moxley Sorrel, would serve as the youngest Confederate general in the Civil War.

By marrying into the Moxley family twice, Francis obtained more than a quarter of the extensive estate in Virginia. But his good fortune was overshadowed by the fact that Matilda was prone to periods of extreme depression.

Could he have turned to his own slaves for comfort and sexual companionship during those trying times? Many slave owners of the era openly had sexual relationships with their slaves, a fact that was ignored by polite society.

MOLLY

Of course, no records exist to support Francis's liaisons with his slaves, but at the time it would have gone against society's very fabric to report such a thing or commit it to paper. It was not uncommon in those days for a wealthy white man to force a slave to become his mistress. Society was expected to look the other way.

As for rumors the slave paid the price of sleeping with her master with her very life, again, such a record would never have been made or kept. The police would not have interfered, and no one would have intervened in her death because she would have been Francis Sorrel's property and his to do with as he pleased.

But would Francis do such a thing? He apparently was quite a religious man, at least publicly. His family pew at Independent Presbyterian Church had been purchased for the hefty price of $1,140, and he was very involved in church activities.

But religious men in the South—and their pastors—could conceivably turn to scripture to justify their slaveholding practices. Consider Ephesians 6:5: "Servants, be obedient to them that are your masters according to the flesh…"

Francis would have heard the words of St. Paul the same way everyone else heard them and as the preacher intended for them to be heard: as a sanction and justification of the institution of slavery in the South.

There was a clear pecking order in the antebellum South prior to the Civil War that was sanctioned by the religious and cultural ethos and enforced by various forms of force, both military and civil. At the bottom of that pecking order was none other than slaves.

They were plainly the property of their masters to do with as they saw fit.

Like many of the elite white men in antebellum Savannah, Francis not only owned slaves but was apparently knowledgeable about where to buy good ones.[37]

Francis's father, Antoine, sent an inquiry in 1827 through a cousin asking where to purchase "20 to 30 slaves from 16 to 18 years of age, well built and of good behavior." He wanted to know how much he should pay for them, and if he should purchase them in Baltimore or Georgia.

Francis indicated his knowledge and experience by quoting what price his father should expect to pay for slaves with good character and without. He told his father to purchase them in either Baltimore or Charleston.

Much is made of the fact that Francis married into a slaveholding family, but he owned slaves before he married Lucinda. Tax records indicate he owned three slaves in 1826, and he sold R.W. Stiles a slave named Melinda in 1829 and one named Louisa, age twenty-five, to W.W. Gordon in 1833 for $400.

The slave census of 1850 indicates Francis owned five slaves in his name who were listed as "Black." They included three females, ages seventy, forty and forty-five, and two male slaves age thirty-five and nineteen.

In another list under the name of Francis Sorrel Trust, eight slaves are listed, all designated as "Mulatto." The females in this list are twenty-two, twenty-five, thirty-five, ten, nine and eight. Two male mulatto slaves are listed as being three and nine years old. The five children on the list were probably children of some or all of the three mulatto women.

Francis could have held these mulatto slaves in a trust for his wife, Matilda, protecting their status in the event of his death. Or he could have used the slaves in his business and housed them elsewhere other than the mansion.

As was the custom of the day, none of the slaves in the list are named.

The most important list for our story is the 1860 census, taken after Matilda's death. That list contains fewer slaves but includes both black and mulatto slaves, all in Francis Sorrel's name.

Slave quarters in the carriage house of the Sorrel-Weed house.

This list contains six "Black" slaves—two female slaves, age fifty and eighty, and three males, age thirty, twenty-seven and twelve. There are two "Mulatto" slaves listed. One was a male, nineteen, and the other a female, twenty years of age.

Two black female slaves appear on both lists. The eldest black female is probably the person referred to in family letters as "ole mammy" or "Old Nanny." One of the Trust mulatto female slaves was probably a person referred to as Nancy in letters, who had a son named Andrew and a daughter named Judy. Judy also had children named William and Nancy.

What cannot be verified is that Francis had a slave named Molly. There are no references in any available family letters of a slave, black or mulatto, bearing this name. However, that doesn't mean one did not exist in the family household.

How he felt about slavery isn't a mystery at all, though. Just because he was born into a country with more slaves than free people, and his father, Antoine, was a supporter of the revolt as far as the mulatto population was concerned, Francis was decidedly not an abolitionist.

In a letter to a friend in Massachusetts who rented a summer home in Virginia, Francis refers to abolitionists as "fanatics" and tells his friend, who

was proslavery, that he must keep his fellow citizens "in the dark as to the number of their nigger brothers you hold in subjugation."

The Sorrel family biographer, Carla Ramsey Weeks, hints at some possible sexual involvement of Francis with the mulatto women in the family trust, at least by cultural association, noting they were all females who had children. Weeks quotes a historian who says there were two thousand mulatto slaves in Savannah in 1860, and that number was indicative of the "master/slave sexual relationships that took place in the antebellum south."[38]

Female slaves were frequently forced to have sex with their masters out of fear of death or being punished. This punishment could also extend to their family members. Masters could sell their slaves at will and sometimes separated family members.

Female slaves had little power to refuse their masters, and there were often benefits from yielding to the demands of their white masters. According to Fay Yarborough, "masters and overseers had power over almost every aspect of a slave's life, and slave women could not freely choose whether or not to enter into sexual relationships with these men."[39]

On the other hand, there were rare instances where it seems female slaves had mutual intimacy with their white masters, and the relationships took on an air of either conventional marriage or the slave being held in honor as a concubine.

But this would not be the case with domestic slaves with a man who was already married. Their sexual encounters would need to be carried out in secrecy.

According to the legend, Matilda jumped to her death in a fit of despair after catching Francis with her slave, Molly. She supposedly jumped headfirst in order to ensure her demise, crashing down on the hard stone in the backyard courtyard.

Did she know something about her husband that caused her to descend into these states of despair? Did she discover Francis's real racial identity? Had losing three children further deepened her mental illness?

MATILDA'S DEATH

Francis and Matilda seemed to be happy for several years, but her depression later worsened, and she suffered from bouts of mental instability. On March 27, 1860, Matilda died after plunging from a balcony outside her bedroom.

The home at 12 West Harris Street, where Matilda may have fallen to her death.

A family friend, Charles C. Jones Jr., recounted her death in a letter to his mother, Mary: "[T]he sad news has reached the office that Mrs. Sorrel, probably in a fit of lunacy, sprang from the second- or third-story window of her residence on Harris Street, next door to the house which was the family mansion for many years, falling upon the pavement of the yard, and by the concussion terminating her life."[40]

The family insisted Matilda fell from the balcony and did not intentionally take her own life—an understandable explanation given the negative associations connected with suicide. Jones's account, however, raises the possibility her death was "probably" the result of a "fit of lunacy."

This understanding of her death was obviously the result of knowledge of her history with bouts of depression. But there may well be another reason Jones suggests she "sprang" to her death.

Francis Sorrel built a smaller house next door to the family mansion in 1856, at 12 West Harris Street, and his older sons, Gilbert and Claxton, moved in. He sold the mansion to Henry Weed on June 14, 1859, possibly to fund a commercial building on Bull and Bay Streets, and moved into the house next door.

If the Sorrels lived in the 12 West Harris Street home when Matilda died, it is difficult to assert she "fell" to her death from a second- or third-story window, given the structural nature of that house. It appears a fall from one of these windows would necessitate an intentional act and, by the looks of the home, a difficult one, at that.

Those who insist Matilda jumped from the third-story balcony of the mansion say Francis struck a deal with Weed to remain in the mansion for an additional six months in order to make repairs to it. There is a historical marker in Madison Square that states Robert E. Lee stayed in the home in 1862 with Francis Sorrel.

In a personal conversation, a tour guide at the Sorrel-Weed house says a niece of Matilda Sorrel confirmed in a letter that Matilda jumped from the mansion balcony to her death.

The author of a recent Savannah ghost book stridently argues the Sorrels lived in the house next door, and thus Matilda couldn't possibly have jumped from the mansion balcony.[41]

But does it really matter where she fell? The end result was the same.

SIFTING THROUGH THE SORREL GHOST LEGEND

One of the first parts of the ghost legend that can be discounted as false is the assertion that public suspicion was raised somehow implicating Francis directly in the deaths of either his first wife, Lucinda, or the deaths of Matilda and Molly.

Quite the contrary, if Francis Sorrel's reputation had been compromised by suspected foul play, he would not have remained on the board of trustees of Independent Presbyterian Church, much less as its chairman. And surely the church members would not have placed a plaque in his honor inside the church sanctuary. The history of the Independent Presbyterian Church indicates Francis Sorrel didn't resign from the board until 1868, when he left due to failing health.

Furthermore, his daughter, Aminta, wrote in her family memoir that Francis was surrounded by "children and friends." She said upon his death, "many of the stores of his tenants on the Bay were closed, and the city court was adjourned in order to allow the members of the Bar opportunity to participate in the sad ceremonies."

It doesn't sound like Francis's reputation suffered because of underground whispers of involvement in scandals. Quite the opposite impression is offered, that he was an esteemed member of Savannah society until his death.

But what about the more juicy and central part of the ghost tale, that he had sexual relations with one of his slaves and that his wife caught him in the act, thus precipitating her suicide? Could that be true?

Maybe.

Francis was harboring at least one very big secret, his biracial heritage. He surely could have managed to keep other secrets from his family and friends if he managed to keep his racial heritage a secret.

The trysts could have been conducted at his place of business, away from the home. Matilda still could have stumbled on them there.

This scenario could account for her periodic bouts of depression, her deepening depression in 1860 and could very well have been one of the reasons for her desperate plunge to death. Or she could have stumbled on Francis with one of the house servants, again, possibly named Molly, at the mansion or in the carriage house in back.

In such a situation, the female slave could have been sent away, sold or, as the ghost legend states, hanged, or she could have committed suicide out of guilt. It may very well be that Matilda discovered her husband with one of his slaves and, in order not to harm him or her children, perpetuated the secrecy and kept it from everyone else.

Her act of suicide could have been the ultimate, deranged sacrificial act in a long line of sacrifices she made for Francis and her family. Francis could have not only "passed" as a white man, but he also could have "passed" as an upstanding moral figure to his associates and church members.

What about the death of Molly in the ghost legend? Versions of it vary from Francis participating in it or members of his family hanging her out of rage to a vigilante mob hanging her and, finally, to Molly hanging herself out of guilt.

However, if members of his family or social friends hanged Molly because of their belief she was responsible for the death of Matilda, then wouldn't they also know that their father and friend was ultimately responsible for her death by having sexual relations with Molly?

Why would they scapegoat the slave woman, when it would have been Francis who was guilty of his wife's death? Slave women had no real choice in the matter, whether they were willing partners or not. However, vigilante mobs do not prey on rational victims, especially when paired with deep-seated racial prejudice.

Unlike the hangings of Alice Riley and Richard White, which are supported by historical documents, there are no such documents to support the hanging of Molly. But that hasn't kept the legend from living on.

A HAUNTED HOUSE?

In 2005, TAPS, best known for the television show *Ghosthunters*, came to Savannah to investigate the Sorrel-Weed House. The team found evidence that the house is haunted and recorded a startling EVP of a woman screaming, "Help! Oh, Francis, help! Oh my God! Oh my God!"

Visitors to the house have reported seeing a woman dressed in black who appears in the basement. Photographs have also been taken that seem to show a woman dressed in black glaring back at the person taking the picture, and there are also photos of a man with a black mustache who is dressed in period clothing.

And what of the little girl photographed in the drawing room? Is she one of the three Sorrel children who were lost before they could grow to adulthood?

Reports of a woman in Victorian dress wandering the house and courtyard continue to be told. Stand in the shadows of that courtyard or in the depths of the house's basement, and its ghosts seem not just plausible but very, *very* real.

AT DEATH, WE DO DEPART

WILLIE AND NELLIE

Not all ghost stories are scary, tragic or sad. Some can be quite beautiful and full of love.

Such is the case with the story of Willie and Nellie Gordon. It is a beautiful story between two people who were madly in love with each other until their deaths. The ghost story is uplifting and magical, not tragic or gruesome at all. Theirs was a bond that would never be broken, not even in death. Their ghost story has been told again and again by tour guides for decades.

Willie and Nellie Gordon were the parents of Juliette Gordon Low, founder of the Girl Scouts of the United States in Savannah. Juliette's parents had an uncommon bond.[42]

They met in 1853 at a party at the Yale University Law Library when Nellie, exhibiting her unorthodox exuberance for life, slid down the banister of a staircase, crashing into Willie and crushing his brand-new hat. It was love at first sight.

Willie knew right away this was the woman he wanted to marry. They did marry and spent many long, happy years together.

But sadly, Willie died in 1912. Nellie was heartbroken and remained in mourning for five long years, until she, too, died.

Willie came to carry her away on her deathbed. He appeared as he had in his prime, dressed in his favorite gray suit. Their daughter-in-law, Margaret, was the first to see him. She watched as Willie left Nellie's bedroom and descended the stairs.

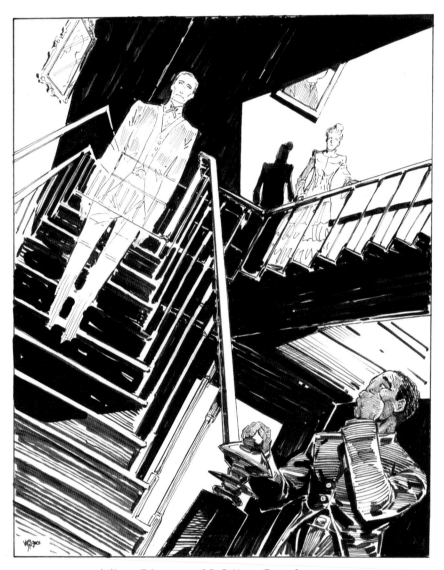

The Ghost of Willie Gordon

Savannah, Georgia, February 22, 1917

Illustrated by Wes St. Claire

At the bottom of the staircase stood the family butler. He, too, said he had seen Willie coming down the staircase going out the front door the way he had done every day for years.

"It was good to see him again. He looked so well and happy, happier than I've ever seen him," he said, tears streaming down his face. "He looked just as he did in life."

The children stood vigil at her bedside upstairs in Nellie's room. "Don't cry for me when I'm gone," she told them earlier. "Everyone should celebrate. I'm going to be with my Willie!"

She soon lapsed into a coma, but just before Willie had been seen on the stairs, her eyes flew open as she sat straight up in bed, her face as radiant as a bride's.

Nellie reached out her arms to someone unseen and peacefully died.

A FAIRYTALE?

Now, isn't that a beautiful story? A man and a woman fall in love at first sight, endure the tragedies of wars and separation and the ravages of time that often drive husband and wife apart from each other, and remain as much in love in the end—and beyond—as they were in youth.

Too bad the story isn't completely true.

Sadly, this ghost story, so beloved by native Savannahians and tourists alike, is filled with errors. About the only thing that is true (the core of the story), other than the dates, is Willie and Nellie Gordon spent many long happy years together—in fact, everyone who knew them said they adored each other.

Their famous daughter, Juliette, would write in a letter to her brother, Arthur, "She never pretended for a moment that he was not her first and last love, and we as nothing in comparison. I believe Papa thought that the triumph of his life!"[43]

Nellie died at home in her bed, so Willie could have come to carry her away. But theirs is not the only ghost story concerning the Gordon family.

There have been many ghost sightings at the family home, today known as the Juliette Gordon Low Birthplace. It is owned and operated by the Girl Scouts and serves as a pilgrimage for thousands of Girl Scouts who come to Savannah each year to visit it. Its staff has had many experiences with previous residents who just don't want to leave their beautiful home.

Willie and Nellie were fascinating people in their own right and really don't need a ghost story to liven things up. They both had numerous stellar achievements other than producing a famous daughter.

Willie, whose full name was William Washington Gordon II, was born into a prominent Savannah family. His grandfather, Ambrose Gordon, was

Home of Willie and Nellie Gordon.

a cavalry lieutenant during the American Revolution. Ambrose named his son after his commander, Colonel William Washington.

In 1815, William became the first Georgian to graduate from West Point. He served as an alderman on the Savannah City Council and was mayor of the city for three years. He also served in the Georgia House of Representatives and the state senate.

But by far, William's most important achievement was becoming the first president of the Central of Georgia Railroad and Banking Company, later called the Central of Georgia Railroad. The railroad provided an essential transportation link for the cotton industry from Savannah to Atlanta. A monument to him and his achievement stands in the center of Wright Square.

One of his sons was named in his honor, our Willie. Young Willie was quiet and serious, a very thoughtful young man.

Nellie was from a prominent and adventurous family that helped found the city of Chicago. In fact, she is believed to be the first white child born in that city. The family was well educated, sophisticated and accomplished. Both her mother and grandmother were published authors.

Life Together

Nellie was raised like most other young women and educated in the domestic arts, such as sewing, cooking and nursing the sick. She attended local schools. She was eventually sent east to a boarding school where she studied art, music, French, Latin and English composition. She was an excellent student.

Nellie became close friends with Eliza Gordon of Savannah, who was Willie's sister. Eliza introduced her to Willie. He was entranced by the comely Nellie and invited her out the following day. Nellie agreed, even though she later said he looked like a "Methodist parson."

Opposites in personality—Nellie was rambunctious and shy, Willie quiet and introspective—Nellie greeted him the next day by sliding down the banisters of the stairs of a friend's home.

They fell in love and were married on December 21, 1857, in Chicago. The mutual vows they made to each other on that day certainly included the traditional Christian marriage vows, with pledges to "have and to hold" each other in every possible circumstance of life, "til death us do part." They made their home in Savannah, living with Willie's widowed mother, Sarah Anderson Wayne Gordon.

The Gordons together had six children: Eleanor, Juliette, George, Bill, Mable and Alice. Juliette was born on October 31, 1860. She founded the Girl Scouts of the United States in 1912.

Life wasn't always plucked from the pages of a romance novel for the couple, though. Like many men, Willie was drawn into the Civil War as a member of the cavalry troop in the Georgia Hussars. He entered the war as a Confederate lieutenant, eventually being promoted to captain.

Nellie was opposed to Willie's decision to "join up" and be sent to the front line of fighting. She wrote quite vehemently about it in her journal: "Now from any sentiment as to whether the South was right; I didn't care a fig for that. I simply did not want him to run the chance of getting shot."

She didn't give a hoot about Northern and Southern politics; unfortunately, her neighbors did. She was viewed with suspicion as a northerner and sometimes verbally abused, especially after it was learned her uncle was a Northern general and her brother an aide-de-camp during the bombardment of Fort Pulaski, on the Savannah coast.

Willie offered to send Nellie and their two daughters to Chicago for the duration of the war, but she chose to remain in Savannah. She spent the time fearing not only for Willie's life but also for the lives of her relatives.

The Gordon family was finally reunited after the war when Willie returned in August 1865. Like many Confederate war leaders, Willie served in politics and continued his military service after the war. He served with the Georgia State Cavalry and also served as a Democrat in the Georgia House of Representatives from 1884 to 1890.

Nellie followed in her mother's literary footsteps, becoming an editor and author. She edited and published her mother's account of the Fort Dearborn massacre and wrote a collection of stories, *Rosemary and Rue*, in 1907 in memory of her daughter Alice, who died as a teenager while she and Willie were in New York City.

ENDURING LOVE

It appears Willie and Nellie's love and devotion, even adoration, for each other never wavered throughout the years. In the 1890s, after they'd been married nearly forty years, he sent her a series of love letters that indicate their love was just as physical as it was emotional.

"I can't write you a long letter and I am too tired to write a sentimental letter," he once wrote. "When I see you," he continued, "I will show you that I love you by petting and caressing and kissing that will be as sweet to me as it can be to you. You know I love you and you must [not] be so silly as to think I care one iota for anyone else."

Willie Gordon died on September 11, 1912, at White Sulfur Springs in West Virginia. He was seventy-seven years old. The resort featured hot springs noted to ease symptoms and help restore health. Nellie followed him in death on February 22, 1927, in her home in Savannah.

Did Willie's ghost return to her at death and take her away with him?

GHOSTS FROM THE PAST

The Gordon house is said to be quite haunted by former residents who are reluctant to leave. Visitors sometimes see Nellie or, more likely, Willie's mother wandering in the garden beside the house.

Figures are seen on the stairs and in the hallways. The ghosts seem enamored with electronic devices, with the staff reportedly finding

Courtyard at the Gordon house.

equipment turned on and mounds of paper printed out upon arrival in the morning when there was no one in the building the previous night.

As you pass the Gordons' former home, glance up at the windows on the second floor. Who knows—you might get a glance of Willie and Nellie, young and vibrant again, stealing a kiss as time marches on.

CHAPTER 5
GHOST JUSTICE

SKEE AND JUSTICE

Drunken men see strange things.[44]
—*Louis Lavater,* De Spectris

Joseph Watson was holed up in the Musgrove trading post for at least three weeks drinking rum with the Yamacraw Indian scout Skee. Watson had a reputation for being a mean and violent man, as far as the Indians were concerned. He had once beaten up the reputable warrior Esteechee for no reason. Watson approached him with a gun out in the woods and threatened to kill him on the spot just because he was an Indian.

Because of the treaty the Yamacraws signed with General Oglethorpe agreeing to constrain their traditional forms of justice with regard to the colonists, instead of killing the drunken Indian trader, Esteechee refused to fight him. Watson beat him up anyway.

The Indian trader and Skee started drinking as soon as Oglethorpe left Savannah in March for England with the Indian delegation.[45] The Yamacraw chief Tomochichi and other important Indians accompanied them.

God only knows what Watson and Skee were up to or what happened in that trading post. You can be sure every kind of *spirit* was involved in the tragic incidents that resulted from the actions of everyone, Indian and Savannah colonist alike, associated with this perplexing and mysterious Indian trader scoundrel, Joseph Watson.

Sometime in late fall 1734, Joe Watson opened his eyes as the first crack of sunlight fell through the window of the Musgrove Trading Post. The walls of the post were spinning round and round and all the trading supplies with them. A hundred demons were colliding in his head. He erupted in a barrage of curses against everything and everyone. He was not happy he was in Georgia, an emotion that rose to the surface whenever he drank rum.

He couldn't focus. He could barely move. A great fear descended on him—he thought a big buck deer head mounted on the wall was chasing him, horns pointed for the kill.

Round and round the furs, corn, rum—especially the rum—and everything else the local Indians traded spun with him. He dragged himself out of bed, took another swig of the rum jug and fell back into his pallet. The Indian warrior Skee was not there.

Joseph Watson was afraid of that fact. He soon passed out again.

For over a month, Indians from the Yamacraw village had come to the Musgrove place and indulged in all kinds of spirited revelry. The Indians came for the liquid spirits and a different kind of company—the liquor mostly.

Watson made the Indian warrior Skee his "particular friend," as he would later tell.

Telling the tale of their drunken revelries as nicely as possible, Joseph Watson and his Indian friends did anything they wanted in the woods away from the constraining presence of the city folk in Savannah.

It is not too much of a stretch to assume Mary Musgrove, the biracial esteemed Indian interpreter and wife of John Musgrove, also occasionally participated in their fun. She was known to host parties at her house during her time in Savannah.

The pleasure experienced from the time these people were together, however, would be short-lived. Tragedy would follow some of them all the way to the grave.

WHEN THE CAT'S AWAY...

The Georgia colony was founded as a forest of possibility for disadvantaged English citizens who desired to profit from the fruits of their hard work. Virtually everyone who came over was given plots of land to cultivate, a task that required a sober and determined community of people who did not

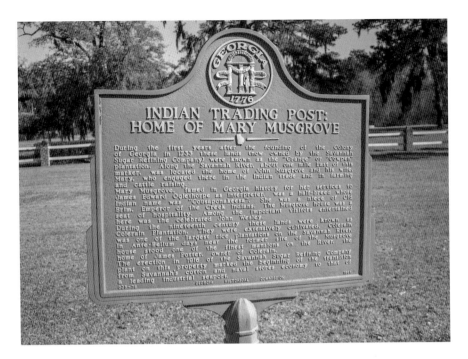

Historic marker for Musgrove Trading Post, Highway 17, Port Wentworth, Georgia.

lay idle all day and night. One of the most deadly and feared drinks strictly prohibited by Oglethorpe was rum or, as it was called, the "Devil's Brew."

This debilitating liquid spirit caused the downfall of many persons, Indians and colonists alike. Oglethorpe knew this and kept a stern eye out for abusers of the policy.

Many people found a way to get their hands on the drink anyway. John and Mary Musgrove were two of those people who not only bartered in rum but also generously provided it to the local Indians and colonists at their trading post, four miles up river from the Savannah settlement. This irritated Oglethorpe, but he needed Mary's interpretive skills in order to keep peace with the Indians.

Joseph Watson, John's business partner, was especially fond of rum, if not downright addicted to it.

THE MICE WILL PLAY

Watson, Joseph—An insolent and vile man…Brought in lunatic.[46]

Saturday, March 23, 1734, was a day of liberation for the Indian trader Joe Watson—at least in the Indian trader's mind.

James Oglethorpe and the Indian delegation were finally leaving Savannah and setting sail for London. They were leaving Georgia, and Watson could not be happier.

The strict general and his senior trading partner would finally be out of his hair, and he could drink all the rum he wanted. The only people Watson would have to deal with were John's meddling wife, Mary, and the Indians. He was finally free in his twisted mind to do what he wanted.

The Indians could also freely imbibe the golden brown, intoxicating liquid as much as they wished without fear of punishment from either side.

After seeing his partner and the delegation off, Watson took the west path from Savannah to the trading post and began drinking.

A Charleston man who did business with Watson, Samuel Eveleigh, reported to Oglethorpe that the trader took to drinking as soon as the general left Savannah in March. He "has been drunk almost ever since you went away," he told the Georgia founder in October 1734. He also added that Watson railed against Oglethorpe and the whole province of Georgia, telling people "he has seen the ruin of two new colonies and doubts not but shall see the third."

On and off for the rest of that year, from March onward, Joseph Watson's drunken ways would get him into a pile of trouble with the Indians and Savannah colonists.

He got into a quarrel with Mary Musgrove in August. In the heat of the argument, possibly over Watson's heavy drinking, he called Mary a witch. The adamant Mary took the case to the Savannah civil authorities and brought charges against him in court. Watson was fined for insulting her and ordered to pay six shillings for the insult to her reputation.

Later that month, on August 24, he tried to shoot her with a rifle in a drunken stupor. The woman overpowered him and broke the weapon.

Mary again took him to court, and again Watson was ordered to pay damages to her, this time five pounds sterling—a considerable amount of money.

As if this crazy drunk had not gotten into enough trouble, the very next day, he was tried by a grand jury in Savannah for beating the Indian Esteechee. He was again hauled into court, ordered to pay thirteen shillings

to Esteechee and repay all the Indians for the stolen goods and suffering at his hands.

That was all well and good, as Esteechee would have his due justice.

Watson was also known for cheating people in business, Indians and colonists alike.

Aware of the dangerous situation Joseph Watson was making between the Indians and the Georgia settlers, Causton went to the Indians and heard all of their complaints against the man. He asked them to state their grievances against Watson.

One member of the tribe, Tallhumme, said that he was once out in the woods stripping bark, and Watson "presented a gun" at him. The Indian said he thought about rising up against the man but "thought better of it."

In desperation, Causton told the Indians that Joseph Watson had been fined and punished for his actions and asked them to forgive him, assuring them Watson would behave. Speaking for all of them, Esteechee, whom Watson had once beaten with fists, said their hearts would never be right with him and further told Causton they wished to trade with someone else. They wanted nothing else to do with the dangerous drunk.

Samuel Eveleigh, mentioned above, had been cheated in a business transaction by Watson, and the South Carolina trader brought suit against him in court for repayment of his due money.

He was also trading and selling behind Mary Musgrove's back by taking his trade into another territory without her consent. This was actually against the law, since Oglethorpe had already set up the proper trading channels for the Savannah traders, and they were not to go outside of their accepted channels of trade for which their contracts were provided.

Causton went to Watson and persuaded him to have someone else come and check his books and the trading post goods. Watson initially agreed, then backed out of the arrangement and kept the keys to the store to himself. A few good swigs from his rum jug surely convinced him this was the right move.

A "SPIRITED" GOOD TIME

These incidents went on for about six months after Oglethorpe's departure. But despite all the trouble Watson had caused the colony and gotten himself into, he apparently managed to capture the confidence and friendship of the

Indian scout Skee. The two men coveted the same spirit, and they had other things in common, as we will see.

Thomas Causton relates the spirited activities that went on between Watson and the Indians at the trading post. The opening lines of his account are worth quoting:

> [Joseph] *Watson, the Trader, as soon as Mr. Oglethorpe departed, gave himself to drinking and was so seldom sober that it was hard to guess if he was not mad. He would be naked with the Indians, drunk with them and lye down with them, and sometimes pretend to baptize them. He made Skee his chief companion, and seemed to apprehend some danger from him, and therefore wanted to make him his particular friend. They were drinking every day together in this way for about a month.*[47]

Even though Watson previously attacked one of Skee's clan members, Esteechee, and abused them in his trading practices, some of the Yamacraw Indians, mainly Skee, decided to continue associating with the man. This seems like strange behavior on his part. Was it because of Watson's rum stash? Were Skee and these other Indians as fond of rum as Joseph Watson plainly was?

Not only were these people drinking together for at least a month, but they apparently were also indulging in other types of human pleasure. Causton's account indicates they engaged in sex on a number of occasions. It also indicates Watson was not only mocking them but also mocking the Christian evangelical intentions of some members of the Georgia delegation.

It might be the case that Skee and his fellow tribe members were associating with Watson in order to eventually harm him for his past abuses, as Watson's later confession suggests. Regardless, we are left with plenty to fill in by way of our imagination in order to understand what happened at the trading post in late 1734.

These two men were intertwined by necessity in cultural and economic forces that seemed to be beyond their control. The friction of their mutual attraction for each other was occasioned, in part, by the fact of them being so close together yet worlds apart culturally.

The tie that kept them together was clearly liquid spirits. Their time with each other, however, would end in tragedies; at this point, the material spirits enter the scene.

ONE DEAD INDIAN

Skee got the flux and went to the cow-pen and died.[48]

Skee ended up dead of the "flux," as the colonists called it in their accounts of the tragedy. His weeks of continuous drinking finally caught up with him.

Watson made trips into Savannah prior to Skee's death and told the colonists the Indian scout was sick. He also told them he was responsible for his illness and publicly bragged about it. Knowing about his drinking habits, they shrugged it off as drunken talk and promptly ignored it.

All of that changed after Skee died. Watson bragged even more after his death and told everyone he was personally responsible for it—even planned it.

The man obviously was not thinking straight, since it was well known Indians exacted revenge on people who injured or killed one of their tribe members.

Thomas Causton, however, was aware of the seriousness of Watson's talk and warned him one day at the public store in Savannah. The unrepentant Watson shrugged off Causton's concern at first and told him "Skee was dead and he alive," further adding, "they both had the same temperament toward one another." Watson is hinting here Skee was trying to either injure or kill him, and that he had gotten to Skee first.

Causton then told Watson he was under too much stress, telling him, "As misfortunes of the world were various," something that happened between the two men had "made too great of an impression on his mind." Upon hearing these words, Watson began weeping and remained silent on the matter. Perhaps his drunken and violent ways were finally catching up with him.

Joseph Watson may very well have thought in his twisted mind he had done a service to the colony by getting rid of a potentially dangerous Indian warrior with the same fondness for women and liquor. After all, Skee was only an Indian, and what good were they in the end, anyway?

And it may be the case Skee knew what he was getting himself into and also may have tried to do Watson in at some point in their drunken association.

Watson, however, was oblivious to one very important fact as a result of the Indian's death—there were other *spirits* for Skee and his kin that did business in the wake of such a tragedy. Joseph Watson's mistake was in ignoring that solid fact.

GHOST IN A DREAM WORLD

The ghost was that portion of the soul that could leave the body during sleep and dreams.[49]

Esteechee was tired and hungry after a long day of hunting deer. The hunting party killed three bucks and hauled them back to their village to be prepared for food. They traded the valuable deerskins at the Musgrove Trading Post not far from their home. The British wealthy coveted them back in England.

The man ate a hearty meal after the work was done, then started drinking rum and got pretty well smashed before he passed out.

During the night, he had a dream he was wandering in a forest. He found himself running through the woods toward an undefined place—toward a vague light ahead of him.

Esteechee ran as swiftly as the deer he hunted, jumping over bushes and creeks. Through the brush he ran. The sun was setting over the purple horizon, and a defined darkness began to descend. The light that was left illuminated the path ahead.

He ran until he came to a large oak tree. In the middle of the tree in the third branch from the bottom was a large white owl. The two creatures stared as if they knew each other.

The bird spread his large wings and flew to the ground. He became something else on the way down. When he landed and turned toward Esteechee, the Indian immediately recognized him to be his friend, Skee.

The ghost of Skee fell to his knees and began weeping. He told Esteeche he was lost and unable to make his way to the path of souls in the Milky Way because an injustice had not been made right.

He begged Esteechee to remain with him in the spirit world—even tried to trick him into staying with him by offering three beautiful deer pelts. "The deer are plentiful here, as well as any woman you want, my friend."

But Esteechee knew it was not his time to wander in the spirit world and ran away from his former friend as soon as the first crack of light from the rising sun pierced the moonless night sky.

The Indian woke up at dawn and took a small band of warriors with him in search of his brother. Skee had been missing for about two weeks, and the rumor was he had been holed up with that terrible man, Joseph Watson.

Esteechee's dream could only mean one thing: Skee was dead. He was now a ghost.

They searched the woods around the Trading Post for about a mile in diameter for two hours. Esteeche smelled something putrid in the air, and they moved toward it.

Sure enough, there was Skee, his body in a thicket in the woods just off the road midway between the Indian village and the trading post.

The Indian scout who Oglethorpe had anointed captain of the Yamacraw militia was dead, his body in the grass next to a tree. It looked as if he grabbed the tree for support as he fell. His face was already purple and bloated. Flies were buzzing around the corpse. He had been there about two days.

The Indians jumped back once they knew what they saw, afraid. Skee's ghost would be hovering nearby, and diseases followed in the wake of contact with the ghost of a corpse. Skee's ghost could curse the tribe, bringing terrible disaster to them all.

Esteechee uttered the first words over his dead friend: "He is dead. His ghost lingers around him."

They sent a holy man who specialized in the spirit world with a group of women, the corpse handlers, to retrieve the body for burial.

BLOOD REVENGE

They believe in inhabited worlds—i.e., planes, both below and above that on which we dwell.[50]

The world that James Oglethorpe and his Georgia settlers entered was a very strange and magical world to those who landed on the banks of the Savannah River. To them it looked like a wilderness of pure cultural and economic possibility as directed by their charter from the English king, George I. It was the perfect place to start another British colony. Yet they would discover taming this raw forest into a profitable British colony was no easy task.

But to those people who had already made it their home many, many years ago, the land was already civilized. Creek Indians inhabited the land. To them it was an enchanted world populated by the bones and spirits of their ancestors. Their ancestors, too, roamed the land, even if the settlers could not see them. These two worlds and the different people who inhabited them would clash on more than one occasion.

The Yamacraw Indians who greeted the Georgia settlers were Creek Indians. They tended to settle along creeks and rivers throughout the entire southeast and had a completely different understanding of the world than their European neighbors. Their world was animated with spirits—not just the spirits of the living and the dead, but of plants and animals as well. Every part of their world and every action they took in it was saturated with spiritual meaning.

There was not just one world for these people—there were three: the Upper World, the Lower World and This World. Their primary concern was to maintain the proper balance between the Upper and Lower Worlds in order to ensure they were healthy and prosperous in This World.[51]

The Upper and Lower Worlds were the supernatural worlds. The Upper World was one of order and purity, inhabited by the creator, who they called "Master of Breath." This supreme being revealed to them the rituals and prayers necessary to reinstate and maintain purity and balance in This World. The Master of Breath bestowed all good gifts to those who kept the proper relationship to him.

Conversely, the Lower World was one of chaos and pollution. It was the place of ominous spirits and ghosts of the dead who could not make the final spiritual journey to the land of blessedness. These people were acutely aware of these two worlds and feared the Lower World with an intensity unmatched by any other indigenous people.

There was very little gray in the Creek worldview. Like many other cultures of people, they divided the phenomena of their experience into dual categories, with each one having its proper place in the order of things. This fundamental duality—man/woman, animal/plant, war/peace, life/death, farming/hunting, sacred/profane—were all distinct and opposite realities. For example, Indian men did not do women's work, which was farming. Conversely, going to war was a man's job, and women did not usually participate. Even though they each had their attendant spirits, plants were definitely not animals. Life functions had their distinct rituals.

The entire way of life of these Indians was centered around maintaining a proper balance between these sometimes warring opposites. But the Creeks understood human beings existed in a place prone to pollution and imbalance and, hence, unease. They accordingly developed and practiced numerous rituals in order to restore any unbalance in their lives.

One of the primary imbalances that they had to address time and time again was the imbalance that derived from an injury or murder of one of their people.[52] Accordingly, the "only truly binding Creek legal code was

based on the law of blood revenge, and it was inextricably linked to their principles of balance and purity and unilateral descent." In such a law, when someone caused the injury of one of their people, the clan of the dead person had a duty and right to injure the person responsible for the initial injury or a member of their clan. The same principle applied to a murder. This was *lex talionis*, or "law of retaliation," pure and simple.

This was not a law that served the utilitarian purposes of conventional justice among a group of people. It was ordained by the "Master of Breath," the creator of the universe. Satisfying the demands of blood revenge reinstated the cosmic balance. While viewed by some European eyes as a sign of their bloodthirsty reputation as "savages," quite the contrary was the case.

A Creek Indian had no choice but to address the imbalance caused by such an event. The imbalance would wreak havoc if it were not addressed, not only on the clan involved but also on a whole tribe of people in the form of diseases and bad crops. They rigorously practiced this law within their own tribe, as well as on any outsiders who violated one or a group of their people.

If a European injured or murdered one of the members of a Creek tribe, he could be sure trouble was on the way. In his 1775 history of the American Indians, James Adair notes that Indians would travel two or three hundred miles to exact revenge on a group or individual. A common saying was that an Indian was never in a hurry "unless he had the Devil on his back."

Any colonial settler who was cavalier about this fact of life among his Indian neighbors was only asking for a heap of trouble.

THE DEVIL ON HIS BACK

In acts of blood, if the offender escapes, his nearest kinsman either real or adopted, or if he had none there, his friend stands according to their rigorous law, answerable for the fact.[53]

The Indians made their way to the trading post with valuable deer skins they wanted to trade. These Indians, however, were not in a good frame of mind.

They were angry over the death of one of their most cherished warriors at the hands of Joseph Watson; the fact that Watson was going around bragging to the colonists he had "done Skee's business" made matters even

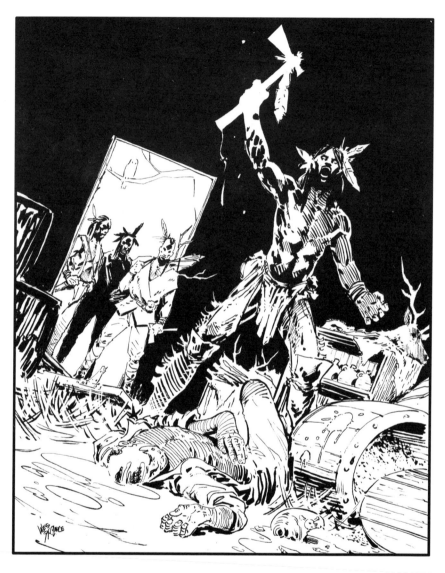

Esteechee's Revenge
Savannah, Georgia, Fall of 1734
Illustrated by Wes St. Claire

worse. Word got around that Watson had been contained in the town limits for his own safety, but Mary would surely do them justice with their pelts.

Esteeche approached the front door of the trading post, knocked hard and announced he wanted to trade. The door was locked. They then heard the drunken voice of a man inside, telling them: "Get out of here! I'm not opening the door to a bunch of damned Indians! No trading today!"

It was Watson. He wasn't in Savannah; he was in the post with Musgrove's slave, Justice.

Furiously mad, they immediately surrounded the house looking for an entrance to get at him. He had injured one of their beloved kin in the most severe way possible, bragging he had killed him. They would not leave until they exacted blood revenge for Skee.

Esteechee vividly remembered his dream of Skee's ghost, and it made him more determined to kill Watson. The man had once beaten him in the woods.

He began banging on the door and shouting, "*Neetak Intahah! Neetak Intahah!*"[54] The building was locked down tight.

Blind with rage, Esteechee kicked and beat against the door until he blew it open with his powerful body. He was yelling at the top of his lungs in a bloodthirsty rage, weapon raised for the kill, looking for Watson.

He raced into the building in a blind fury and struck a swift blow against the head of the first human figure he saw, bringing his tomahawk down with the force of three men on Justice, the black slave of John Musgrove.

Watson wasn't in the post. Prior to Esteechee's entrance, Mary Musgrove, the very woman who had sued Watson in court for calling her a witch and practicing witchcraft and whom Watson earlier tried to kill, warned him of the Indians and helped him escape, leaving poor Justice to reap the consequences of their retribution. Because of Mary Musgrove, the murderous drunk, Joseph Watson, was alive, and poor Justice was dead.

Needless to say, this thickened the plot considerably.

"JUSTICE" PURSUED

Thomas Causton acted immediately to address the volatile situation. In a letter to the Georgia Trustees in England, he wrote, "The murder justly alarmed us." Causton was afraid the bloodshed on the part of the Yamacraws would continue, even though from their worldview, a life had

been taken to restore the imbalance caused by the death of Skee. As far as Esteechee's clan was concerned, the matter was likely over. The Georgia settlers, however, had a completely different understanding of what constituted justice in the matter.

Causton ordered some of his associates to escort Esteechee, who had been coming into town, to the "Indian line" and not enter the town until the situation was resolved. Causton notes, "He has kept away from the town ever since."

The chief magistrate then turned his attention to Watson. He ordered associates to the post to give an account of the trader's records and the goods in the store. He called a grand jury to investigate the events that led up to the death of Skee and murder of Justice.

The town waited three months for the findings of the grand jury, which concluded the following: "Finding [Watson] continued his drunken humors, and that the public danger rather increased, for his own killing of Skee had reached Tallahumme's ear…there was nothing to hope for but the immediate confinement of Watson to secure his life." Watson offered bail, but the magistrate denied it. He was confined to house arrest and prevented from leaving the town or drinking any more rum.

Causton's course of action against Watson resulted in a curious reaction from the Savannah residents. Many people were outraged that a free white man would be confined to house arrest for killing an Indian. In the same letter to the Trustees, Causton relates, "An opinion is now started that it is very cruel to imprison anyone for fear of an Indian." He notes, "Many of our new politicians think it is more for the interest of the province to let an angry man go out of it…than to gently confine him to his own house." Peter Gordon stridently objected to Causton's verdict and actions and offered again to pay for Watson's freedom. Causton refused.

Even the town minister, Samuel Quincy, objected to the "harsh" treatment given to Joseph Watson and urged Causton to listen to the will of the majority of people. Public opinion was mounting against Causton, and a group of men became advocates for Watson's freedom.

Under severe criticism, Causton told the Trustees he jailed Watson "to preserve him from the Indian resentments, [and] also from dangerous company." The "military gentlemen," however, are "too apt to think that the orders of the magistrates are to be executed as they think fit." He told the English noblemen in desperation that "until some of your advice comes, it is very difficult for the magistrate to help it."

What About "Justice?"

I have lost my servant man, Justice.[55]

Skee's death was avenged by the standards of justice practiced among the Yamacraw Indians. While their target was the man directly responsible for the Indian scout's death, any member of the extended clan would suffice to avenge the demands of their world creator. Whether out of a blind rage or a calculated act, Esteechee murdered the slave and property of Watson's partner, John Musgrove.[56]

Not much was said about the murder of Justice by the citizens of Savannah, and it seemed to signify to the Indians their prized balance in the order of the world had been achieved. While his death surely shocked the Savannah residents, they were mostly concerned about it because they feared the retributive violence by the Indians would continue. The only person who stridently reacted to the slave's death was his master, John Musgrove.

Musgrove wrote to the Trustees after his return to Savannah. After hearing of his partner's "proceedings and abusing the Indians," Musgrove insisted he could no longer be in business with him. Watson protested after hearing this and insisted on continuing their contract for an additional four years.

But John would not hear of it. Not only did Watson kill an important Yamacraw Indian, he also attacked his wife in his absence and conducted a series of shady business deals. And most importantly in Musgrove's mind, Watson was indirectly responsible for the death of his slave. Musgrove thought "it not proper to be concerned with [Watson] any further."

His primary complaint, however, against Watson because of the death of his slave was totally personal in nature. In Justice's absence, he would be forced to plow his own fields, which would hamper his trading business with the Indians. John Musgrove was not so much lamenting the death of Justice but rather complaining that his death would cause him added work. The taking of an innocent life doesn't even concern the esteemed trader.

Musgrove's business opportunities with the Creek Indians upriver would be severely hampered as a result of his slave's death.

The bottom line in this violent spirited and drunken affair was that the only tragedy in the death of Justice was his personal and economic loss to John Musgrove. None of the Indians or Savannah colonists considered his murder to be of much consequence. No one cared about Justice except Musgrove, and he primarily lamented his death in economic terms and the added burden his death would cause him personally.

The trustees handed down their own brand of justice a few months later. They applauded the imprisonment of Joseph Watson on the grounds of all of the trouble he had caused for both the Indians and colonists, forgave Esteechee for his actions in response to the death of Skee, which was the murder of Justice, and repaid the Indians who had been cheated by Watson.

Everyone seemed pleased with this verdict. Everyone, I'm sure, except the ghost of Justice.

SAVANNAH GHOSTS ROAM THE WESTSIDE

The Musgrove Trading Post was located about four miles west of Savannah. John and Mary Musgrove were living and trading with the Indians before Oglethorpe arrived in 1733 on the site that would become the city of Savannah. The Musgroves moved upriver and built their post along the banks of the Savannah River when the settlers arrived.[57]

The site where the trading post was is now owned by the Georgia Ports Authority, and a container berth was built where the post stood. An archaeological dig was conducted by the Southeastern Archeological Services in Athens, Georgia, in 2002 before building the container birth. They discovered the foundations of the trading post and three cellars full of such things as rum jugs, bottles, pottery chards, gun flints, coins, buttons and even the still-intact skull and antlers of a deer.

After the Musgroves passed from the scene and the Yamacraw Indians with them, the trading post became part of the large rice plantation called "The Grange."

Michael Harris, co-author of this book, had his own story to share:

I lived close to the site of the trading post in one of the factory houses where my father worked for the Savannah Sugar Refinery (which made Dixie Crystals Sugar), located in Port Wentworth, Georgia. The historical marker for the Musgrove post is located on refinery property off U.S. Highway 17.

I roamed the whole property as a kid, day and night, with my friends. I remember encountering numerous strange men who would walk through the area.

We tried to avoid these strangers out of fear and would run and hide when we saw them. Many of them, or perhaps all, were homeless, and sometimes they would hop a ride on the train that ran through the area to someplace else.

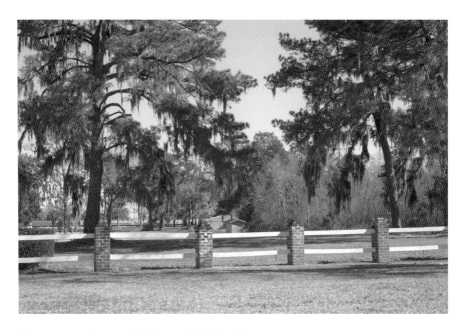

Site encompassing part of Musgrove Trading Post.

One man in particular who often came by was a man named Chuck. For some reason, he didn't seem as intimidating as the other men who I saw walking by. He became something of a friend. He told me and my friends about the ghosts that roamed the area on one occasion.

I distinctly remember him saying, "Now y'all kids be careful where you go around here, especially at night. There are ghosts that haunt these woods. I've seen 'em with my own two eyes. They are the ghosts of Indians, and if they can, they'll take you with them. They'll kill you if they can!"

Then he turned and walked away, laughing to himself. Of course, this scared the devil out of me, and I ran as fast as I could for home.

I rarely saw Chuck again, and while his story frightened me, it didn't stop me from roaming the area at night. I still ran with my friends, climbed trees and swam in the huge ditch down from the house when it flooded. But every time after that when I saw something shadowy or heard a strange sound, and I often did, I would be reminded of Chuck's words about the spirits that roamed the area, causing a strange, chilling fear to descend on me.

I'm not sure if Chuck made up these stories just to scare us, or even if he suffered from the same fondness for liquor as Joseph Watson and Skee, which he probably did, or if he indeed saw ghosts in the area. But I do know one thing: there were strange and threatening presences in the woods around that sugar refinery, and my father would tell me of unusual things that went on inside the plant—things that literally went "bump in the night."

CHAPTER 6
BONES, BURIALS AND GHOSTS

TOMOCHICHI AND OGLETHORPE

*Out there somewhere
a shrine for the old ones,
the dust of the old bones,
old songs and tales.*
—*Gary Snyder, "Old Bones"*[58]

Interest in human bones extends thousands of years into the human past. Contrary to most contemporary perspectives on human remains, bones have been associated with life rather than death throughout the vast majority of human history. Bones possessed mystic powers for most of our human ancestors, ranging from cure and divination to birth and rebirth.[59]

All human bones, however, are not created equal. Skulls, vertebrae and shoulder blades were believed to contain special powers that lent themselves to ritual significance. Scapulimancy, a practice dating back to Babylonian times, is a form of divination that involves studying the pattern of cracks and fissures in bones heated in an open fire. The cracks formed a type of interpretive map of answers to important questions that only the initiated were able to read, much like a fortuneteller does for people's palms.

The first humans were actually created from bones, according to the earliest Hebrew creation story, "bone of my bones" (Genesis 2:21–22). Other ancient people believed skeletons and bones could be reanimated and were essential to human rebirth. In such cases, bones were preserved after decomposition and treated with special care.

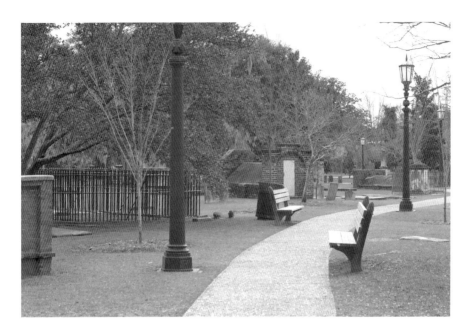

Colonial Park Cemetery.

Brick burial vault at Colonial Park Cemetery.

Certain Native American Indians placed their dead on a high platform in the woods away from the clan. After a period of time in which the body was sufficiently decomposed, they would return to the corpse and carefully remove the flesh, returning the bones to be buried in ancestral burial sites. Many cultures from the past have placed important items in the tombs of the dead—items, it was believed, they would need in their journey to the spirit world.

Skeletons, in particular, have the power to unnerve even the most skeptical human being. What person's interest isn't slightly peaked when confronted with the appearance of a human skeleton? This fascination has characteristics of a "sacred" experience and is not unlike Rudolf Otto's famous definition of the sacred as the "mysterious fear and fascination" of holy things.[60] Burial sites, skeletons and human bones simultaneously attract and repel us.

Further and most importantly, human beings are the only animals that bury their dead. Some animals eat their offspring under certain circumstances. Higher primate animals usually observe the change in their kin and then depart. Conversely, human beings bury their dead and have established elaborate rituals to mark the transition from life to death.

In addition to the numerous reasons for burials across cultures, one was to prevent the "ghost" or revenant of the dead from harming the living. As we shall see below, many practices associated with burials were introduced to prevent this from happening.

The literal bones of Savannah's two founders, Yamacraw Indian chief Tomochichi and General James Oglethorpe, would become not only important, even precious, to some of those who followed, but they would also evoke their own share of controversy among the living.

ANCESTRAL BONES

"A Very Uncouth Hollering"

We return to the historic square from which we began our journey through some of Savannah's ghost legends, Wright Square. Our infamous lovers, Alice Riley and Richard White, if you remember, were hanged there for the death of their master.

In addition to being the first place of public execution in Georgia, the "hanging square," it was also the place where the Indian chief Tomochichi was laid to rest in 1739. So this is a particularly rich area not only for Savannah history but also for ghost haunting.

While there is no detailed ghost story associated with Tomochichi, there is a legend told to young people who wander into the square. It is said if children run around Tomochichi's burial rock three times and place their ears close to the large granite bolder marking his grave, they can hear the voice of the old chief calling to them from the grave. Some also say the spirit of the old Indian wanders throughout the square and surrounding area, calling out in his native tongue to those with "ears to hear."

As we will explore below, the area that was populated by the colonists was already a land scattered with the bones and spirits of the first natives when it was renamed Savannah.

The Indians who lived in the Savannah area introduced themselves to the green English settlers with much fanfare after they arrived in 1733. One of their principal men, the head warrior, led the procession, prancing and dancing in full dress, in "antic postures," as one settler would call it, recounting their people's exploits in battle. Much of what was recounted amounted to "a very uncouth hollering" to their very British ears. Yet for the Indians who greeted them on the Savannah Bluff, what their leader was recalling was no less than the sacred acts of their people.

Tomochichi recounted why the Yamacraw Indians settled in the area years ago in his first meeting with Oglethorpe. They migrated to the spot not only because it was near a vital river but also and equally important because their ancestors were buried in the area. It was to discover "good land near the tombs of my ancestors," the chief told the British general.[61]

As such, what would become Savannah and Georgia proper held "spiritual significance [as] the resting place" of their descendants. To the Indians, this meant not only were their ancestral remains located nearby, but their ancestral spirits roamed the land, too, infusing it with a vital force.

A 1757 map of Savannah by William de Brahm lists a site in the western part of what is now the Savannah historic district, just outside what was then Trustees Garden, called "Indian Hill." That Indian burial mound was surely part of the "resting place" of Tomochichi's ancestors. It was

Site of former Indian burial mound at Emmet Park.

located northeast in the city, at Bay and Lincoln streets outside the old "Trustees Garden Gate." It was subsequently razed in later years and now corresponds to a plot of land northeast of Habersham and Bay streets in Emmet Park.

A later map of the city, Charles Platen's 1875 map of Chatham County, does not show Indian Hill, since it had been razed more than one hundred years before, but it does show an Indian mound just off White Bluff Road near what was Good Hope, called "Indian Mound," as well as a mound called "Cherokee Hill" off the old Augusta Road in West Chatham County.[62]

There was a widespread belief during the time of Oglethorpe that the great English explorer Sir Walter Raleigh visited the Savannah Bluff and interviewed an Indian chief in the sixteenth century.[63] Oglethorpe believed this legend.

In his *History of Georgia with Maps of Original Surveys*, de Brahm describes the mound and his version of its history as follows:

> *Between the City and Trustees Garden is an artificial Hill upon the Bay,*
> *part of which in 1760 was dug through…whereby a Stratum was opened*

near the Plane of the City filled with human Bones; this confirmed the
History of this Mount, which had traduced it to be an ancient burying
Ground on which…one of the Yamacraw Kings had entertained a great
white Man with a red Beard, who had entered the Port of Savannah
Stream with a very large Vessel, and himself came up in his Barge to
Yamacraw, and had expressed great Affection to the Indians, from which he
hath had the return of as much.[64]

This legend of Raleigh visiting Savannah is false. Raleigh never traveled to America. Dolores Floyd argues the explorer was Jean Ribaut, a French explorer who traveled to southeastern America in 1562 and founded Charlesfort, on what is now Parris Island, South Carolina.[65] She also connects Ribault with the famous Irene Indian mound located about four miles west of Savannah, which was very close to Tomochichi's Yamacraw village.[66]

There were numerous Indian burial mounds located in and around the Savannah colony during the time of Oglethorpe and Tomochichi, and these mounds were one of the reasons the Yamacraw Indians settled the area.

TOMOCHICHI'S TOMB

Tomochichi expressed a desire to be buried among his British friends in Savannah prior to his death on October 5, 1739. Many have interpreted this to signify his close relationship with Oglethorpe, yet there is another equally important, perhaps greater, reason for his request. He simply wanted to be buried among the remains of his ancestors.

Regardless of his motives, his burial ground in Wright Square would prove to be controversial to this very day.

Oglethorpe demanded a British-style burial for the Indian chief. The town clerk, William Stephens, writing to the Georgia Trustees in 1739, describes the burial:

[A]nd that the most material thing worth noting, was the death of the old
chief, Tomochichi…And as [Oglethorpe] always esteemed him a friend
of the colony, and therefore showed him particular marks of his esteem
when living; so he distinguished him at his death, ordering his corpse to be

brought down. It was buried in the center of one of the principal squares,
the general being pleased to make himself one of his pall-bearers, with
five others…At the depositing of the corpse, seven Minute guns were fired,
and about forty men in arms…gave three volleys over the grave, which the
general says he intends to dignify with some obelisk, or the like, over it as an
ornament to the town and a memorial to the Indians.[67]

His grave monument was an obelisk, which appears on the abovementioned de Brahm map under the name "Tamachychee's Tomb," located in the very center of what is now Wright Square. Tomochichi's tomb was likely the first such public monument to a public figure in America and was "utterly unique in commemorating a Native American."[68]

The significance of this monument, however, would not be held by Savannahians very long. The majority of the Yamacraws left the area by 1750 for larger towns inland; they simply faded into the background of Georgia history after a few years.

To signal their insignificance to Savannah, Georgia Royal governor Henry Ellis proposed a public market be removed to "Thomoe Chichi's Burial Place" in 1759.[69] After its appearance on the de Brahm map, the tomb does not appear on any further maps of Savannah. The mound simply disappeared over time.

DISPUTED BURIAL/DISPUTED BONES

A decorative mound proposed by a city alderman was built in the square in 1871. It was not, however, associated with the burial place of Tomochichi. It was one of three such mounds built in the center of squares. A photograph exists of the mound, and it is generally mistaken to be the chief's burial mound. This is not the case.

The mound was removed in 1882 to make way for a large columned monument to William Washington Gordon. Gordon was a very prominent industrialist in Savannah and Georgia and the founder of the Central of Georgia Railroad and Banking Co. The monument reflects his importance to the people of Georgia as founder of the first railroad.

William Washington Gordon monument, Wright Square.

Tomochichi's Rock

"All Georgia Dust"

Ironically, it was William Gordon's daughter-in-law, Eleanor Gordon, president of the Society of the Colonial Dames of America in Georgia, who led the way for a new monument for the Indian chief. It was reported the Gordon family opposed the monument to their patriarch, perhaps fearful of disturbing the resting place of the Yamacraw chief.

Eleanor was raised among Indians in the Northwest Territory and was sympathetic to their plight. So the Colonial Dames arranged for a large granite bolder to be shipped from Stone Mountain and placed on the southeast side of the square, since apparently some felt his grave had been desecrated.

The boulder approximates the obelisk shape of the Indian's first memorial, coming to a sharp point on the left side. The granite company gave the boulder for no charge, but the Colonial Dames insisted on paying for it—they gave the company one dollar.

Tomochichi's burial rock, Wright Square.

Savannah's socialites gathered on the square on April 21, 1899, to commemorate the event. Judge Walter G. Charlton delivered the memorial for the new Tomochichi monument.

After finally celebrating Tomochichi in his lengthy paean of gratitude for his efforts in establishing Georgia, Charlton feigns ignorance of the exact whereabouts of the Indian chief's remains and tells the crowd it really doesn't matter in the end, since he is "all Georgia dust by now, and all Georgia is his grave."[70]

The bones of the old Indian chief, along with his headdress, blanket and weapons, remain buried under the Gordon monument to this very day, despite assertions to the contrary.

VICTORIAN BURIAL CUSTOMS: QUEEN VICTORIA'S LOSS

The Victorians most embraced death in modern times, due in part to the influence of Queen Victoria, devastated by the sudden death of her forty-two-year-old husband, Prince Albert.[71]

Gothic burial vault at Laurel Grove Cemetery.

Struck down by typhoid fever in December 1861, Albert's death left a hole in the queen's heart that never healed. She spent the remaining forty years of her life grieving for the husband she adored. She stayed in seclusion and wore black for the rest of her life. Her obsession with mourning made wearing black more fashionable.

The Victorians intimately lived with death as they moved through life, and it's no wonder. It was an era when only one in four children lived to adulthood.

After Death

Curtains were drawn and clocks were stopped to mark the time of death when someone died. Mirrors were covered with crape or veils to prevent the deceased's spirit from getting trapped. A wreath of laurel, yew or boxwood would be tied with crape or black ribbons to the door to alert passersby.

The wake was the three-day period in which the body was watched over every minute until it was buried. This practice served two functions: to give friends and family private time with the deceased and to prevent someone in a coma being buried alive.

Embalming did not become common until the Civil War. Flowers and candles would mask the stench of death for the duration of the wake, usually three or four days.

A door was taken down to carry the dead from the house. The expression "at death's door" derived from the practice. The dead were always taken out feet first in the coffin or on a door so that he or she could not look back at the house and the spirit remain or, worse, beckon another member of the family to follow.

Family photographs might be turned facedown to prevent the spirit of the deceased from possessing any family member.

Some Victorian houses had a niche, or "coffin corner," cut into the stairwell so that the coffin could make the turn to the outside of the house.

The "cooling board" was a special board used to hold the body before an autopsy or before it was placed in the casket. Some houses were built with a showcase window where a coffin could be placed so passersby could stop and pay their respects.

Doors had special significance as the symbol of the passing from life to death. Along with windows and portals, doors were used on funerary statues to symbolize the passage from this life to the next.

Food also played a large part in a funeral, at least for the living. Neighbors often carried food to be consumed at the wake, and a collation, or lavish meal, would be served after internment. Small cakes, called "funeral biscuits," were wrapped in white paper and sealed with black wax and given to friends as favors.

Most graves were laid out so the head pointed west and feet east because of the belief Judgment Day would come from the east. The righteous could then literally rise "feet first" to enter their glory.

THE IRISH WAKE

The Irish wake had its own particular customs. The windows were opened when a person died, and women gathered to wash and dress the dead. Not surprisingly, whiskey was involved in the rituals, being poured on the deceased's favorite possessions in their honor. A fiddler or piper called in to play might also pour some on his instrument.

Some Irish wakes became quite rowdy parties, with the dead called in to participate. Sometimes the corpse was taken out of the coffin and dragged around the dance floor, had a glass or bottle of whiskey put in his or her hand, or had a hat put on the head. Everyone wore black to appear as a shadow so the corpse's spirit would not enter a living person.

White was often used in children's funerals. The child would be carried in a white coffin by women dressed in white, including white veils, and the coffin and ostrich plumes were also white.

THE RULES OF MOURNING

There were strict rules for mourning—and following them was expensive! Only the wealthy could afford all the trappings of mourning their dead. Wives who lost their husbands were required to dress in black for a year and a half. Those who could not afford to buy a new dress could dye their clothes black.

The widow went into "half mourning" after this time, which meant adding a touch of gray or white to her outfit. Some jewelry would be permitted, and black clothing could be made from fabric that had a sheen to liven it up.

Permitted gems for adornment included jet, onyx, bog oak, vulcanite and gutta percha. Small pearls symbolized fallen tears.

The widow could begin wearing colors after two years. Young children were often required to wear white trimmed with black or gray while in mourning, and even their dolls would be dressed in appropriate mourning colors. Two years was the acceptable time for a widow to grieve for her husband, while children grieved for their parents and siblings for a six-month period.

Even personal stationery and handkerchiefs carried a black border to symbolize the death of a spouse. If the death was very recent, the border was very wide.

PICTURES OF THE DEAD

The invention of the daguerreotype in 1839 and production of prints brought about a revolution in the way human beings depicted themselves. Of course, the "photograph" would make its way into every facet of human activity, from depictions of the ravages of war to pictures of the dead.

Families of deceased persons began having photographers come to the house and take photos of the departed, which were then shared with family members and friends. While some of the photos depict the deceased lying in a casket, many mourners chose to have the dead person posed and painted to look alive for the photo.

Not only were bodies posed through the use of armatures and other contraptions, they were often posed with family members as if they were interacting with them. Eyelids would be propped open, and in cases where this wasn't possible, eyes would be painted on eyelids to give the photo a more realistic look. Cheeks would also be painted pink for the appearance of a vital healthy glow.

While this practice might seem strange to us today, perhaps even a bit pathological, it reveals the Victorian's intimacy not only with their loved ones in life and death but also with death itself as a natural and, indeed, expected part of life.

Hair from the dead was sometimes used to make jewelry worn by survivors. Hair jewelry might be worn during the second stage of mourning. Some pieces were metal forms containing bits of hair, and other pieces were made from full strands.

In addition to bracelets, brooches, rings, chains and buckles, sculptures were created from human hair. Different shades of hair were used to give the sculptures depth, and when completed, they would be kept under glass or put in a frame for safekeeping.

Hair was used because it does not decay for hundreds, perhaps thousands, of years. Hair jewelry peaked in popularity in the United States around the Civil War.

Death masks were also used to make mementos. Wax and plaster cast was used to preserve their likeness so that portraits and sculptures could be made later.

SOME VICTORIAN SUPERSTITIONS

It is not unusual the Victorians developed what seem to be bizarre superstitions concerning the dead because of their familiarity with death. Many of these were associated with nature, including flowers.

They believed flowers would bloom on top of their graves if the deceased lived a good life. Only weeds would sprout, conversely, if the person was evil.

The scent of roses if none were around offered a premonition someone was going to soon die, and the scent of a person's favorite perfume meant their ghost was hovering nearby. Having only red and white flowers together in a vase, especially in a hospital, meant death would soon follow. A single snowdrop growing in the garden foretold death.

Large raindrops in a thunderstorm meant that someone had just died, and rain in the open grave of the newly deceased meant a family member would die within a year. But rain on a funeral procession meant the deceased would surely to go to heaven, and a thunderclap following burial meant their soul had already reached the pearly gates.

Birds and insects were harbingers of death. A pecking bird on a window meant someone had died, as well as a bird's airborne crash into the windowpane. The cry of the curlew and hoot of an owl foretold death, as well as the presence of a firefly in a house.

If a household had been the place of many family deaths, a black ribbon was tied to every living thing that entered the house, from dogs to chickens.

Wearing new clothes to a funeral was forbidden, especially shoes. Meeting a funeral procession head-on was bad luck. If one was encountered, people

would try to turn around, and if not possible, one was instructed to hold on to a button until the funeral cortege passed.

These are just some of the strange beliefs associated with the mysterious presence of the dead among the living.

BURIED ALIVE

The boundaries which divide Life from Death, are at best, shadowy and vague. Who shall say where one ends, and where the other begins?[72]

Perhaps the most interesting and understandable fear people had in the nineteenth century about death was the possibility of being buried alive. The fear began on a widespread level in the eighteenth century, showing up in literature and pamphlets on the subject. It came to a peak during the Victorian era because of the adolescent advances of medical science and the fact that this new science was not always capable of delivering on its promised goods. In short, doctors were not always able to correctly diagnose when a person was actually dead.

On rare occasions, a person having succumbed to a coma, cataleptic trance or some other illness with death like symptoms was thought to have departed this world. So a very real fear was being buried alive.

The London Association for the Prevention of Premature Burial, founded in 1896, published no less than seventeen pamphlets on the subject, including such titles as *In Dread of Premature Burial, Burying Alive* and *How I Was Buried Alive.*

The famous Gothic writer Edgar Allen Poe wrote a story entitled "The Premature Burial," where he stated this "ghastly fear" was, beyond doubt, the "most terrific…extreme which has ever fallen to the lot of mere mortality."[73]

In one episode of this premature subterranean fate, Poe tells the story of the wife of a prominent lawyer in Baltimore who had supposedly died. Describing the body, he says her lips "were of the usual marble pallor" and her "eyes were lusterless." She had no pulse. She lay for three days unburied, after which she was promptly deposited in the family vault.

The vault was reopened for another family member three years later, but "a fearful shock awaited the husband" when the tomb was opened. At the door were the skeletal remains of the wife, which "fell rattling in his arms" as he entered.

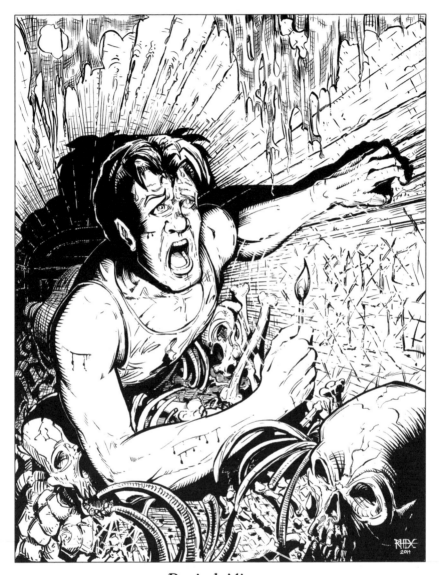

Buried Alive...

A 19th Century Dreaded Fear

Illustrated by George R. Hicks

It seems the woman wasn't dead at all when buried. She desperately tried to escape the hermetic box when she awoke, causing it to fall to the floor and spring open. The remains of the broken coffin revealed she had desperately tried to break open the door of the mausoleum but got tangled in the iron bars next to the entrance, where she "remained, and thus rotted, erect."

Coffins were invented that could be opened from within, and ropes running to the surface of the grave, attached to a bell, could also be rung in case someone taken for dead came back to life. All they had to do was ring the bell and be rescued, if lucky enough for someone to hear it, and be "saved by the bell!"

BODY SNATCHERS

Grave robbing was another real Victorian fear. This practice began because doctors recognized their students' need to dissect corpses in order to become good doctors. A growing business soon developed, and as many as forty thousand bodies a year were stolen for medical examination. Body snatchers, or "resurrection men," stole bodies from cemeteries and sold them to medical schools.

Body snatchers worked in groups, scouting for fresh graves because they were easier to dig. After exhuming the body, they would cover the grave to make it look undisturbed.

Starting at the head of the grave, they would remove dirt onto a canvas tarp so the nearby graves would appear to be undisturbed. The coffin lid would be pried open, and the body stripped of all clothing, which was placed back in the coffin.

The bodies were then sold to medical universities for use in educating student doctors. The practice was more prevalent in large urban cities, like New York, Philadelphia and Baltimore, but preventive measures were taken in smaller cities like Savannah.

People of every age were stolen from their graves, young and old alike. In addition to bodies, valuables, such as jewelry, were also taken from graves.

Savannah's older cemeteries, including Colonial Park and Laurel Grove cemeteries, contain crypts and family vaults. These brick stone "buildings" were constructed with entryways buried under the ground to prevent access to the crypt. The crypt was located down a set of stairs with shelves where new bodies were laid.

Nineteenth-century tombs at Laurel Grove Cemetery.

Ornate family burial vault, Laurel Grove Cemetery.

Metal coffin dredged from the Mississippi River. *Photo used by permission of Old Town Trolley Tours, Savannah.*

Additional bodies were added over time. When it became too crowded, the bones of the oldest remains would be placed in an ossuary, or bone box, in the center of the room. The new body would be placed where the old one had been. Recycling at its finest.

Over time, coffins were made more difficult to pry open. Metal coffins were introduced to prevent bodies from being stolen.

OGLETHORPE'S TOMB: THE BODY SNATCHER

Great Oglethorpe, awake from visioned sleep!...At last, thy morning dawns and thou cost rise, a King![74]

Dr. Thornwell Jacobs had a great idea in 1913 to resurrect Oglethorpe University on a plot of land in Atlanta. The university thrived under his leadership. It is the only university bearing the name of the Georgia founder.

He had another brilliant idea in 1922. Since the university bearing Oglethorpe's name was up and running, why not bring the general's remains back from his musty grave in England and plant him squarely in his proper and true home, Georgia soil?[75]

He conceived a daring plan to access key people in England and received permission from the English government to bring James Oglethorpe back to Atlanta to be planted like a sturdy oak in the center of the university.

Oglethorpe and his wife, Elizabeth, were buried under the floor of All Saints Church. But Thornwell encountered two problems. One, the British government did not have authority over the general's bones. That authority resided with the Rector of All Saints Church, the Reverend Leslie Wright.

The second problem was the old church had been demolished and rebuilt in 1875. No one knew exactly where Oglethorpe's bones might be under the new church structure.

To further complicate the matter, authorities directed the parish to remove all mural tablets in the reconstruction of the new church, thus erasing any markers that might locate the general's remains. No one knew where he was buried under the church. Jacobs knew he could not pursue his petition unless he could convincingly establish where Oglethorpe's bones were underground. Needless to say, people in England were somewhat perplexed at the university president's adventure.

He contacted as many U.S. and British public authorities as he could, claiming that Oglethorpe was perhaps "one of 100,000 great Englishmen." One local British newspaper quoted him as saying the General "represented all that is best in Georgia's founding, history and traditions." The search for Oglethorpe had piqued the interest of many in England by this time—what was this crazy American up to?

Thornwell searched the old archaeological records and determined he had found the place where the body was underground. The new church had been raised up on the old foundations, which meant the dimensions of

the new structure were the same. He convinced the chancellor to reverse his decision, and excavations began on October 9, 1923.

The Associated Press reported the event, noting the stillness of the church was interrupted by the sounds of birds chirping and the heavy sounds of hammers and chisels.

The excavation crew removed bricks and found a crypt underneath on the morning of October 10. One of the excavators cried, "There it is!" Excited beyond belief, Thornwell nervously asked, "Can you read the name plate?" He began to cry, too moved to speak. "He stood transfixed as if he was in another realm."[76]

Thornwell lowered himself into the crypt like he was descending to the abode of a long-dead god, assisted by none other than Hermes himself.[77] He saw what seemed to be gold and silver lacework in the flicker of candlelight. Dark coffins lay side by side at the bottom.

Dr. Thornwell realized he was closer to James Edward Oglethorpe than any living Georgian had been since the early days of the colony. Overtaken by emotion, he solemnly said, "James Edward Oglethorpe is no longer a bit of dust or a group of relics" and boldly predicted the general "was about to become the most dominant personality in the state of Georgia."[78]

Thornwell Jacobs had succeeded in discovering the grave of the Georgia founder. However, his efforts soon regressed into a catfight over the body, despite initial enthusiasm and support on both sides of the Atlantic. Certain prominent Savannah citizens, led by Noble Jones, argued that if the general's body should rest anywhere in Georgia, it should be in the seat of his former home, Savannah.

Governor Clifford Walker refused to forward the State Department request because he thought Oglethorpe's remains should lay in the state capitol, not at Oglethorpe University. Jacobs would later lament, "Overnight the whole plan degenerated from a dignified and reverent request of a University… and became a scramble over dead bones between two American cities."[79]

The British press quickly got into the controversy, lamenting the way Oglethorpe's remains were being treated. The *London Daily Express* indignantly labeled the whole affair an "Atlanta College Stunt" and ridiculed Jacobs and his fellow Georgians as "body snatchers." The paper also accused Jacobs of committing "sacrilege" against Oglethorpe.

Jacobs withdrew his request to bring Oglethorpe back to Georgia only six days after discovering the founder's body.

CHAPTER 7
HIGH NOON

JAMES STARK AND PHILIP MINIS

The Villainy you teach me, I will execute, and it shall go hard but I will better the instruction.
—*Shylock,* The Merchant of Venice, *3.1.61*[80]

It was a hot and humid August in 1832 Savannah. The air hung like a smoldering fire from a blistering sun, oppressing everyone. Men, women and children were sweating profusely under the blazing inferno—heat felt by all. No one could escape its wrath.

There was another kind of heat felt by two men engulfed in a dark comedy of errors that would, in the end, turn into a full-born tragedy. What happened in Savannah that year was like an old western movie, with the usual good and bad guys.

Sometime around midafternoon on Thursday, August 9, James Jones Stark and Thomas Wayne, rifles in hand, entered a boat on the banks of the Savannah River and made their way to Scriven's Ferry in South Carolina, just up the coast to Beaufort. The trip took about an hour; the two men made small talk about the heat and the reason for the trip.

"Do you think he will show?" Stark anxiously asked his friend Wayne.

"How should I know?" Wayne replied. "Spalding said they wouldn't be there."

"It's damn hot," Stark said.

"How accurate is your rifle?" Tom Wayne asked his friend.

"It shoots pretty straight when I aim it just to the left of the sight."

"That's good to know, I guess," said Tom, "just in case they decide to show."

The two men landed at the ferry on the South Carolina side of the state divide about four o'clock. The field was empty—not a person in sight. The air seemed heavier and hotter than before. They were both sweating and thirsty. The cawing of a few crows overhead and the sound of crickets pierced the deafening silence like a second hand counting down the minutes.

Stark quickly raised his rifle to shoot one of the crows from the sky; he missed, and then the birds scattered and were gone.

They anxiously waited, sweating under the oppressive heat. Each minute seemed like an hour. They kept their eyes fixed on the water, vainly searching to see if another boat was approaching before the clock struck five o'clock.

Stark clumsily practiced his aim, holding his rifle with his nervous hands at his side, as if it was a pistol, then bringing it up for a fire. He practiced his quick draw over and over, just to see how fast he could fire without shooting himself in the foot.

He took a swig of whiskey to calm his nerves and steady his aim.

"Why did I insist on this damn rifle for a duel?" he said.

"I suppose because you don't have another gun," retorted Wayne. "You don't have another gun, remember? You had to sell all your others because your momma and daddy disowned you. Hell, all you have left is your sniveling sister. Nobody else in your family will have anything to do with you!"

Stark didn't reply and kept fumbling with his rifle. "Well, I'll piss on him one way or another in the end," the duelist said.

Wayne pulled his watch and looked at it. The hands were approaching five o'clock. Wayne looked at his friend and remarked, "Looks like they won't show."

"I guess not," Stark said. "I knew Minis was a coward."

Then both men raised their rifles into the empty blue void. Stark yelled triumphantly as he fired, "Minis is a damn Jew coward! Hell yeah!" firing off three rounds into the blue dome above. Stark yelled again, "I knew he was a Shylock! Wait 'til we get back to town. The Jew-bastard will be run right out of Savannah!"

The two men quickly got in their boat and made their way back to Savannah. When they reached town, they celebrated their hollow victory throughout the city's drinking establishments on the bay.

Why did these two men go to South Carolina and shoot rifles into the sky, all the while mocking a Jewish doctor named Philip Minis, when they were told beforehand he would not be there?

Who was Philip Minis, and what did he do to James Stark to make him so hell-bent on shooting him in a staged one-man duel?

This black comedy would be anything but over by the end of the day. One of them would be dead before the clock struck noon the next day. Here is the story that led to the fateful encounter on August 10, 1832.

Ghost Legend

The ghostly reverberations of a lengthy social conflict between James Jones Stark and Dr. Philip Minis in 1832 can still be felt in the Moon River Brewery Company on West Bay Street in Savannah.

The popular establishment is located in the former City Hotel, a Regency-style hotel built in the early nineteenth century that was touted as the best drinking establishment in south Georgia. All kinds of people gathered there, men mostly, to conduct their business,

take a good meal and down a hearty round or two of the finest wines and liquors in the area.

The hotel would be the site of a number of tragic events over the years, but the one that took place around noon on August 10, 1832, between Stark and Minis would outrage members of the city's respectable judicial and clerical establishments, as well as serve as a comedic episode ripped from the pages of a Shakespearean black comedy.

Old City Hotel building, now Moon River Brewery Co.

The second, third and fourth floors of the building are said to be haunted, not just by the ghosts of Stark and Minis but others too. Construction workers have experienced inexplicable footsteps in otherwise vacant parts of the building, voices emanating from vacant rooms and the like. Three construction crews have left their renovation projects, refusing to do further work.

Ghost tour participants and employees have reported experiences of being pushed or shoved while walking down steps, in addition to pieces of clothing being jerked and grabbed by someone or something. The ghosts at Moon River are said to be "pushy." A ghostly woman in nineteenth-century attire has also been spotted by a number of guests roaming the upper floors' halls.

Our focus is not on the building, per se, but on the tragic events that transpired between Stark and Minis, which came to a bloody denouement in the old City Hotel, leaving an indelible ghostly imprint on the building and those who wander its halls.

INSULTS: ORIGINS OF THE FEUD

James Jones Stark and Dr. Philip Minis had a lengthy dispute beginning in the spring of 1832, lasting at least five months. Both were men of honor from prominent families in Savannah's social elite class.[81]

Minis traced his prominent family heritage back to the founding of the city, being among the first Jewish families to settle in the colony in July 1733. Stark's family belonged to the elite plantation class in Georgia, in Glynn County, just below Savannah.

Both were younger men in the prime of their lives, below thirty years of age—somewhat wild bucks, so to speak. They gambled, engaged in the sporting crowd and drank, of course. Those who tell of the ghost story in print and tours say the dispute began over a game of quoits, a game much like modern-day horseshoes.[82]

Minis thoroughly drubbed Stark in the game, which infuriated him, according to the ghost legend. This led to a series of public insults and slanders by the hot-headed Stark against the good doctor, which, in turn, led to a series of emotionally charged events in the lives of the two men—events with fatal consequences for one and a trial by fire for the other.

But like all deep-seated conflicts between human beings that will not seem to go away, the reasons for the Stark and Minis "affair of honor," as it is called, are deeper and more injurious than a mere game of quoits.[83]

What else happened between these two men to incite such vitriolic hatred? There's more to the story than a game.

One day in the spring of 1832, Philip Minis and James Stark, both with friends in tow, were at the local horse racetrack, Ten Broeck, west of downtown Savannah.[84] Minis was talking to friends about what to name a horse he had apparently purchased. Stark was either present or nearby and overheard the conversation.

According to witnesses, Stark said to Minis, "Name him Shylock" and afterward, perhaps away from him in the company of his friends, called Minis a "damned Jew."

These were fighting words. Sally Minis, the doctor's sister, was apparently present and said her brother "challenged him then," at which time, she says, Stark apologized. However, after thinking about the incident under the influence and persuasion of friends, Stark retracted his apology; word of Stark's retraction got back to Minis.

The public vitriol continued on Stark's end sometime later at a bar called Luddington's. Drinking with friends and surely under the spirited influence of liquor, the conversation turned to Philip Minis.

Meaning to publicly report, once and for all, his true feelings and prove he had not apologized to Minis, Stark silenced his friends and loudly blurted, "Philip Minis is a damned Jew who ought to be pissed upon!" Stark was clearly stoked for a fight and tried to kick up some dust with a friend of Minis's who was there, Richard Arnold. Arnold wasn't interested in tangling with this drunk, hotheaded fool.

Stark continued his bad talk against Minis, so some friends of the doctor went to him that night and told him of it. Minis then hurried down to the bar. A hush fell over the room as he entered the barroom and seated himself in Stark's company.

When Minis sat down, Stark said, "Minis, I am damn glad you are here." Minis stayed a while in his company, but Stark kept his mouth shut and said nothing derogatory about him.

Minis later asked Arnold what Stark said after leaving the bar. Arnold refused to tell him, explaining he thought it was a "matter of indifference" and the whole affair over.

How are we to understand the events up to this point in the story? What is so important about public insults uttered in this early nineteenth-century context, insults that may seem paltry and insignificant for us today, and why did they sometimes result in potentially deadly encounters?

MEN OF "HONOR"

When a man of honor is told that he smells, he does not take a bath—he draws his pistol.[85]

What distinguished the South from other regions of the country in the early nineteenth century was its stubborn commitment to the honor code. Dueling and the public challenge to a duel emerged from this social code. If an elite white male publicly insulted one of his peers, such a man was forced to address the matter or else suffer the shame of humiliation.

Inherited by wealthy American white men from their European ancestors, dueling had a long history involving prominent military, political and wealthy men of notable standing in American history.[86] By the early nineteenth century, the time frame for the Stark-Minis affair, it was largely relegated to the South.

The honor code was not just a moral virtue separate from other aspects of men in the South; it constituted the very fabric of social standing and commerce. It was, in short, the social "credit system" by which a white male could be judged worthy of friendship, business transactions and marriage. In effect, men of good honor were on the side of truth and not to be publicly slandered by one of their peers in any way.

If a white male's honor was injured by one of his social equals by way of verbal insult, such a man had no option but to respond or else be deemed a coward, shunned and cut off from friends and business opportunities.[87] There was money involved in responding to a duel issued by one's peers, not to mention social advancement.

This complex code was a thoroughly public display, revealed in how such a man dressed, walked, talked, acted toward people in public and, most importantly, responded to conflict and insults with other men. All of the public gestures of these men were taken as one fabric of their true status in society.

The central controlling factor for a man of honor was his public projection of himself.[88] The most important feature of the elite white male in the South was his face, especially his nose. Great care was taken to preserve the face, with the nose leading the way as he moved about socially.

As we will see, all of these factors play out in the Stark-Minis affair in intricate ways. But what about the nature of the slanders against Dr. Minis? What significance do they hold?

SMACK TALK

"Shylock"

Fair sir, you spit on me on Wednesday last; you spurn'd me such a day; another time you called me a dog; and for these courtesies I'll lend you thus much monies?
—*Shylock,* The Merchant of Venice, *Act 1.3.121-124*[89]

Stark's initial "smack talk" was the "Shylock" remark at the racetrack in spring. He may have already been badly beaten in the game of quoits, maybe earlier that day, but this particular insult carries a good deal of negative weight for a Jewish man and clearly intensified Minis's anger.

Shylock is an infamous character in Shakespeare's dark romantic comedy *The Merchant of Venice*. Stark obviously had the bard's play in mind with the remark, at least the common meaning of the slur.

Without belaboring the intricacies of the play, suffice it to say Shylock is an infamous Jewish loan shark who loans money at interest and becomes rich from the practice. In the play, Shylock loans money to Antonio, a Christian merchant in need of funds until his prized ship returns with fortune. In exchange for the money, Shylock sets up the terms of the loan in order to exact "a pound of flesh" if Antonio isn't able to repay the loan on time. Antonio agrees, knowing his ship will return in time.

Shylock is subjected to a number of insults and personal assaults from Antonio and his friends throughout the play, mostly ethnic in nature, denigrating his Jewish identity. The derogatory term took on a social meaning since Shakespeare to become a general insult leveled at Jewish businessmen by their gentile neighbors.

When his antagonist, Antonio, is unable to repay his loan, Shylock demands a "pound of flesh" from him according to the terms of their contractual agreement. That is, Shylock wishes to cut a literal pound of flesh from Antonio with a knife. He wants blood to flow; he wants him dead!

In street talk, the term "Shylock" implies a person whose only interest is exacting exorbitant rates of interest on money loaned to others, seeking revenge if they aren't able to repay the money.

Is this what Stark had in mind when he leveled the insult at Minis? Was Stark inferring Philip Minis was a loan shark? Or was the insult merely a general ethnic slur meant to harm? Did Philip Minis loan money to his friends or associates and exact a pound of flesh, one way or another, from

them? Did Philip Minis loan money to James Stark at one time in the past at a high rate of interest, forcing Stark to pay?

Or more likely, did the two men engage in bets with one another (over a game of quoits?) and Minis take Stark to the proverbial cleaners?

IT'S GETTING HOTTER OUTSIDE

If a Jew wrong a Christian, what is his humility? Revenge. If a Christian wrong a Jew, what should his sufferance be by Christian example? Why, revenge.
—*Shylock,* The Merchant of Venice, *3.1.68–71*[90]

Our story left off with Minis and Arnold leaving Luddington's after confronting Stark and Arnold, suggesting the affair was of no real concern.[91] We pick it up at this point.

Not satisfied either way, Minis later employed a friend named Bryan to write Stark and inquire about the nature of his comments at the bar. After hearing back from Stark, Bryan went to Minis and said he was "totally satisfied with Stark's explanation, that it was satisfactory in every way."

We can see the development of the duel taking place. Instead of writing directly to Stark, which was not socially acceptable at this point, Minis is using his friends to act as intermediaries, or "seconds," according to the dueling codes, in order to diffuse the conflict. Minis may have thought the matter duly settled.

However, the good socialites of Savannah would not let it end so quietly or quickly.

At a Fourth of July celebration at the Mansion House, a local boardinghouse and hotel, the affair came up again—it was the topic du jour.

There was talk of Stark having offered an apology, which would have ended the matter. But a man named Sturges, apparently an associate of Stark, insisted Stark did not offer an apology. He said Stark justified himself concerning his statements but did not intend for them to be taken as an apology.

Minis had Bryan write Stark again concerning this deepening morass. Bryan became more direct in this letter, asking Stark to clarify the reports being bandied about Savannah about Minis, which seemed to be that Minis demanded an apology but Stark refused to offer one, so Minis backed out of the conflict without his honor being regained. If this was the case, Bryan said, then Stark needed to apologize.

Stark replied that he had nothing to do with the reports being thrown around town. He acknowledged he had "done an unnecessary injustice to Dr. Minis, but did not intend it as an apology to him." Stark was extending the insult even further, since he acknowledged he performed an unnecessary injustice to Minis but refused to apologize for it. He was in effect saying Minis was worth insulting but not worth an apology.

Excuse the pun, but was James Stark "stark-raving mad?"

Minis had but one recourse to action after hearing of this outrageous attack—write Stark directly and demand satisfaction—which he did, demanding "that satisfaction which one gentleman should afford another."

Stark replied Minis "should have satisfaction," and his friend, Thomas Wayne, would make the necessary arrangements. The duel was officially on!

BULLETS THE BLUE SKY

The brain may devise laws for the blood, but a hot temper leaps o'er a cold decree: such a hare is madness the youth, to skip o'er the meshes of good counsel the cripple.
—*Portia*, The Merchant of Venice, *Act 1, scene ii, lines 15–18*[92]

Before continuing with this intriguing story of human conflict, let us look at another perspective by a contemporary of James Stark that may shed a bit of light on his otherwise inexplicable actions.

Writing after the conflict came to its inevitable tragic end, Savannah native, Harvard graduate and poet Robert Habersham offered revealing information about Stark.[93] He says Stark had been "a dissipated young man" who had "broken the heart of his mother." Further, everyone in his family had "dropped off except one sister."

He changes course later in his journal and offers a positive estimate of the quick-tongued rascal from Glynn County, calling him "a brave, honorable, young man, very promising in his profession, with excellent talents."

How can Stark one minute be dissipated and a disappointment to his family and the next honorable and brave?

What happens next in this drama reveals James Stark to be anything but brave and honorable. We pick up the sad saga again.

At noon on August 9, 1832, Thomas Wayne presented articles outlining a duel to Philip Minis's friend and second for the contest,

Charles Spalding. The articles insisted rifles were to be the weapon of choice and the duel was to take place at 5:00 p.m. that afternoon at Scriven's Ferry in South Carolina.

Spalding objected to the use of the rifle instead of the usual weapon for duels, the pistol, as well as the time suggested in Wayne's articles. He said Minis would consent to the use of rifles if Stark would have it no other way, but neither he nor his friend, Philip Minis, could possibly be there that afternoon.

Spalding submitted his own articles in response to those of Wayne, after consulting with Minis, which he had every right to do according to dueling codes, and said Minis's rifle was at the gunsmiths. Five hours to prepare was not enough time, Wayne insisted, for Minis to get his affairs in order.

He also said Minis would gladly duel James Stark anytime he desired the following day, and with the unusual weapon, a rifle.

Wayne said Spalding could not object to the articles because "no preliminaries were discussed." Wayne left informing Spalding that he and Stark would be at Scriven's Ferry that afternoon for a duel at 5:00 p.m. whether Minis showed up or not.

Sure enough, Wayne and Stark proceeded to Scriven's Ferry, and at 5:00 p.m., with Spalding and Minis absent, the two men "made a flourish, shot rifles…and returned to town flush with a victory over the—air."

When they returned, the rumors, spread by Stark and fueled by Wayne, immediately began circulating that the two men had officially agreed on a duel at 5:00 p.m., but Minis "forgot the hour," thereby implying he had chickened out. These rumors imprinted the assumption previously circulated around town to the people of Savannah that Philip Minis was guilty of the worst possible offense for a man of honor—cowardice.

It should be noted Stark and Wayne did not proceed with the duel according to the usual standards employed by two men and their seconds. In order for a duel to occur, the various *code duellos* insisted the two parties must come to total agreement on the weapons, time and place. This did not happen in this case.

Minis and Spalding had the right to object to the time of day, and Stark and his associate would have to comply with their wishes in order for the duel to occur within the proper restrictions of the dueling code. Minis agreed to the unusual rifle but insisted he could not meet until the following day. This

should have satisfied Stark and Wayne, but they proceeded on their own course of action, oblivious to the consequences that would follow.

Something now had to be done by Minis. The social line had been crossed; there was no turning back for either man.

Things Have Changed—A Pound of Flesh

If you prick us, do we not bleed? If you tickle us, do we not laugh? If you poison us, do we not die? And if you wrong us, shall we not revenge?
—*Shylock*, The Merchant of Venice, Act 3.1.54–56[94]

Stark and Minis would occasionally pass each other on the street during the months leading up to the culmination of their conflict. Minis would present himself in a cool and respectable manner each time, "nonchalant," according to one witness, even presenting a "full face" to Stark on one occasion.

As he did early in the dispute at Luddington's bar, Philip Minis was demonstrating he was not afraid to confront his antagonist when he seated himself among Stark and his friends in the aftermath of public insults. Minis was in effect giving Stark the opportunity to "unmask" him as a coward and further shame him before the eyes of the public.

But Stark did nothing but walk by each time they passed, usually with his friend Wayne in tow. He was heard on one occasion to halfheartedly say, "Let's go back and whip the damned rascal!" But Wayne said no.

By the morning of August 10, 1832, the day after they went to Scriven's Ferry for the mock duel and returned to slander the doctor, Minis had had enough. Reports were circulating around town that he was a coward. People were publicly laughing at and about him, ridiculing him.

Minis's friends warned him to arm himself, and armed he was. Stark and Wayne were at the City Hotel, so he made his way over with his pistol. Philip Minis was going to put an end to this one way or another, come hell or high water!

With his friends Charles Spalding and Octavus Cohen, Minis entered the hotel about 11:45 a.m. and went to the barroom. The bar was crowded that Friday morning with some of Savannah and the surrounding area's wealthiest men.

Second-story stairwell at Moon River Brewery Co.

Second-story room where James Stark stayed.

A hush descended on the bar when Minis walked in. Everyone looked at him as he slowly and deliberately took his place. The men in the bar were busy talking about the day before.

Stark was upstairs in a room where he had stayed overnight. Minis summoned him to come down and join him for a drink. The doctor waited as the minutes felt like hours. He was shaking inside, going over in his head what his next move would be when he spotted Stark, if he came down at all.

Minis ordered a shot of whiskey and quickly downed it. The warm spirit elixir calmly settled in his stomach, and he felt a soothing heat rush throughout his body. He was ready for anything now.

Stark slowly descended the stairs, hung over from drinking the night before. Minis stood and turned toward him from across the room. When Stark's feet hit the bottom floor, he advanced toward his opponent. Minis reached his right hand into his coat pocket, quickly pulled his pistol, pointed it at Stark and loudly cried: "I pronounce you, James Jones Stark, a coward!"

Stark was already reaching into his vest pocket to pull his weapon, but he was too late. Minis fired a single shot that hit its mark. Stark slumped against the wall next to the barroom entrance and instantly fell dead.

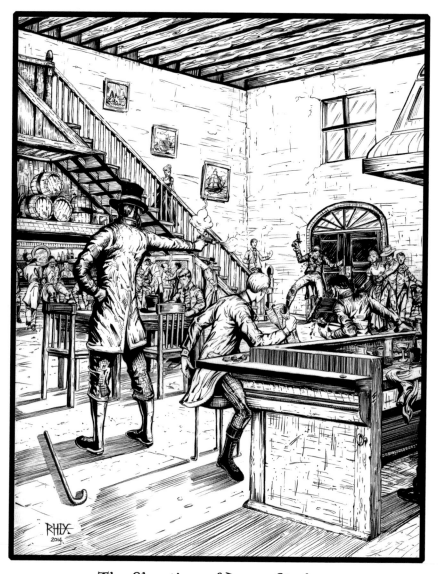

The Shooting of James Stark
The City Hotel, Savannah, Georgia, August 10, 1832
Illustrated by George R. Hicks

Unlike Shylock in *The Merchant of Venice*, who was prevented from exacting a pound of flesh from Antonio, Minis got his from his antagonist—he ripped a straight-line bullet through Stark's chest the size of a silver dollar! The conflict was finally over, but Philip Minis's actions only opened the door to another one for him.

AFTER THE DUST SETTLED—MORE DUST

Minis was immediately seized by the onlookers and witnesses to the shooting in the commotion that followed. Arnold says he thought Minis had been mortally wounded, because his hat had been knocked off and he was in a panic seizure.

Minis appeared to be in a state of "convulsion, held in somebody's arms." He was still holding the pistol and "swore he would fire into the crowd" if anyone tried to harm him.

Spalding, his friend and second for the conflict, approached him and persuaded him to hand over his pistol, which he did. Arnold then approached the doctor and told him he needed to leave the City Hotel and go to his office. He helped Minis leave by giving him his horse and buggy, and Minis proceeded to his office, followed by Arnold on foot. Minis waited until the authorities came for him.

By this time, a crowd had gathered outside in the square waiting for the sheriff. The crowd began to start rumors that said Stark was unarmed and had no pistol when Minis shot him. Minis willfully surrendered to the authorities and awaited trial for murder.

An interesting fact in this violent episode is that public sentiment was overwhelmingly of the opinion that Dr. Philip Minis committed cold-blooded murder against an unarmed man. During Minis's stay in jail, a group of vigilantes damaged his office or, as Arnold again tells us, "nobly wished to wreak their vengeance on the boards and plastering of his office by pulling it down."

"TO SUCCEED THE TRAGEDY OF YESTERDAY"—A FARCE

Arnold recounts an interesting affair connected to the shooting but not recounted by anyone who tells the story. Writing in his diary on August 11,

he states: "To succeed the tragedy of yesterday we had a farce today enacted by Rose & Balfour & Brown." This "farce" seems to be directly related, as parody, to the Minis shooting of Stark.[95]

It seems two of the men, Rose and Balfour, pretended to have a quarrel between them, and when Balfour drew a pistol retreating from Rose, he cried, "If you come any closer to me, I'll blow your brains out." Balfour seems to be mocking the very words Philip Minis had used the day before after he had shot Stark. Rose then left, "loudly declaring that Balfour was a coward."

Later in the day of the shooting, Balfour had beaten Rose with his umbrella, and as a result, Rose was laying in wait for Brown at Gaudry's store with a gun. Arnold notes that "these affairs being known, as some fun was expected, a great crowd soon collected in and about Gaudry's."

A policeman picked up Rose and took him to jail since he was carrying a gun and lying in wait for Balfour. Justice Pelot interrogated Rose and asked him, "Did you not say you had loaded this pistol for the purpose of shooting John Balfour, our fellow citizen?" Rose replied: "No, I did not. I said I loaded to shoot John Balfour, but *not* 'our fellow citizen.'"

A man named Dick Wayne, who had gone to the jail to see Rose, then picked up the pistol, placed the barrel in his mouth and "blew through the touch hole." The gun wasn't even loaded! Arnold says the "crowd dispersed in universal [laughter]."

Balfour seems to be playing the role of Minis here and Rose that of Stark. Balfour mimics Minis's words to the crowd after he shot Stark, and Rose seems to be pulling Stark's verbal shenanigans when Stark admitted he had insulted Minis throughout the affair but did not mean it to be taken as an apology.

This apparent mockery of the Stark-Minis tragedy gives us telling information of how involved the entire community was in their "affair of honor." It wasn't just a two-man show. There was an ever-waiting and baiting audience all across town.

Murder or Self-Defense?

James Stark went to Scriven's Ferry the day before he was shot and played out a mock duel with his friend, Thomas Wayne, against an absent adversary, claiming a hollow victory when he didn't show. The two men

didn't even bother to take along a standard accompaniment for duelists—a doctor, in case someone needed medical attention. Both men knew Minis wouldn't be there.

Philip Minis entered the barroom of the City Hotel the next morning and called out Stark. The Glynn County planter reached into his vest pocket after descending the stairs, advancing toward Minis. The doctor then promptly shot him through the chest as he moved toward him. Philip Minis exacted his pound of flesh. James Stark was dead.

Minis didn't have to shoot twice, and he didn't waste his bullet in the ceiling above. He went, one could say, straight to the heart of the matter, ending the conflict.

Both men's families were terribly shaken by the events. Stark's sister was thrown into a "stupor" that lasted for months, going about town wearing black, the color of mourning. Habersham, a neighbor of the Minis family, reported hearing "the loudest weeping and lamentation from Mrs. Minis' house," noting "it seemed as if the whole house had burst into one cry of mourning."[96]

One prominent group of Savannah citizens were duly alarmed over the shooting—the members of the Anti-Dueling Association. Formed in 1827 by the town's leading clerical and judicial men, the association had prevented a duel from taking place since its inception.

While the association members intervened in the matter, sending letters to the two friends and intermediaries in the conflict, Wayne and Spalding, asking to help steer the matter to a peaceful conclusion, they jumped in too late. In an effort to vindicate themselves given the death of Stark, the secretary, William Bee, ripped off a defensive response in the association minutes on the afternoon Stark was shot.[97]

Bee says the "extreme indisposition of the secretary" prevented the calling together of the standing committee to investigate civil matters, which could end in a bloody conflict. Thus, the association was slow to act in the affair.

Letters seeking to intervene into the bloody conflict were not sent until August 10, the day after the mock duel and morning of the shooting. Bee says he sent letters to the two friends, Wayne and Spalding, and further notes Spalding was not home at the time of delivery, so word of the association's interest did not even reach him or Minis.

The members of the committee, at least Bee, quickly formed an opinion on the City Hotel shooting: Minis was guilty of cold-blooded murder. With Bee as their spokesman, he insisted, "Stark was attacked and slain with a pistol, at the City Hotel, on the bay by Dr. Minis." He also notes Stark was

in the act of responding to the association letter when he was called down to the barroom by Minis.

He ends his account of the event by saying his record is made, "lest it should ever be inquired, where was the Anti-Dueling Association, and its Standing Committee on this occasion."

No doubt the association's perspective was influenced by Judge Law, a superior court judge and prominent member of the Anti-Dueling Association. The judge was also a cousin of James Stark by marriage.

Law pressed Richard Arnold to publish the findings of the coroner's report in his *Georgian* newspaper, which precipitously stated Minis was guilty of murder. Arnold objected to the coroner's report, stating Minis was not a murderer based on a medical investigation of Stark's corpse, since he had not yet been tried in court; he refused to publish Law's ad hoc opinion, even though he was a judge.

So Minis languished in jail for months, accused of murder, and waited for a trial until a replacement for Judge Law could be found—the judge was excused because of his kinship to Stark.

TRIAL

The trial took place in January 1833. Minis had three of the finest lawyers on his team, two from Charleston. Witnesses came forth from both sides. The question of Minis's guilt hinged on who drew first and whether or not Stark was drawing for his pistol when Minis shot him.

Stark's friend, Wayne, testified he tried to take Minis's pistol from his hand when he saw him draw and temporarily lost sight of Stark. Stark's friend insisted he could not discern whether Stark's pistol was drawn when Minis shot.

Spalding, on the other hand, said he saw "something presented before Minis fired." Others testified to that effect too.

It was enough evidence to convince the jury, which acquitted Minis of murder and set him free.

Minis would later move to Baltimore, Maryland, to live out the rest of his life, marry and become a doctor to native Indians. He is buried in Laurel Grove Cemetery in the Minis family plot.

MOON RIVER HAUNTING

Moon River Brewing Company is touted as one of the most haunted buildings in Savannah. The TV programs *Ghost Adventures* and *Ghost Hunters* have featured the building and its many ghosts on their programs.

One of the more popular ghosts haunting the building is a shadowy figure about the size of a boy, who the staff affectionately refers to as "Toby." His preferred abode is the basement of the building.

One of the more ominous and, frankly, acerbic ghosts is the "Lady in White." She haunts the upper floors of the building and is responsible for more than one renovation crew abandoning its work in the building, refusing to return. Her shadowy figure has been seen and heard by a number of employees and ghost tour guests.

And, of course, our own James Stark's ghost is said to haunt the main floor, where he met his death, as well as the second floor where he was probably staying when the good Dr. Minis came to pay his final respects.

CONCLUSION

We arrive where we began at the beginning of our journey through some of Savannah's most interesting ghost stories—the ghosts in the ghost story. Without these ghosts and their tales, we would have no book. Like the seemingly shy and reticent ghosts who carefully pick and choose their appearances, often leaving a void of silence for the seeker rather than the fullness of vision, we would have nothing to tell.

Perhaps we have expanded these stories in the course of our investigation into a larger appreciation of the central characters who, by ill fate or a peculiar kind of destiny, occasionally roam the very places of their not-so-fortunate personal cul-de-sac.

Alice Riley keeps looking for her lost baby, James. But as we hope to have shown, she could just as well occasionally return to that former "hanging square" looking for the head of her accomplice, Richard White, who may have forced her into the dastardly deed. If they were lovers (it is difficult to tell from the sources), then her search for the baby must be coupled with her lingering love for him.

What about Richard? There are no ghost appearances attributed to him. But that doesn't mean he doesn't appear now and then from the shadows of an alley to survey the landscape.

Or perhaps Alice is looking for the man who fathered her child, if it was not Richard. We make the informed guess she might have been framed for the murder, in which case, who knows why she occasionally wanders the

square at night. Maybe she is searching for her own brand of justice on a life that was anything but easy.

James Stark's ghost still keeps company at the Moon River Brewery Co. His sudden apparitions reflect what we know about his hotheaded "affair of honor" with Philip Minis. Stark's ghost is reported to be "pushy," an ethereal descendant of the same man who boasted a mean gun but in reality couldn't seem to shoot anything but his own foot in the end.

He simply pushed the wrong man too far and paid the price with his life. I imagine if you ever encounter him at the brewery you could back him off quite easily with a sudden "Boo!" Stark talked a mean duel but in the end, it seems, learned a major lesson in the most difficult way: don't mess with a surgeon, as they tend to go straight to the heart of the matter! Remember, a city barroom is not an operating table, and the code duello is not the Hippocratic oath.

Francis Sorrel and his philandering ways, if one can call them that, revealed another interesting facet of Savannah's company of ghosts: people aren't what they seem to be or are more than they appear on the surface of things. His poor wife, Matilda, suffered from what the monks of the fourth century called the "noonday demon." She was never able to shake them from the cobwebs of her tortured mind.

From our perch into their lives with the ghost story in view, Francis did everything he could to ameliorate her condition yet fell prey to his inner libidinal compulsions, or lusts, if you will. Quite simply, the man, like most everyone else, harbored secrets from his past, secrets about the color of his inherited blood, because as was the case in his day, the bottom line of every bartered dollar in the antebellum South boiled down to the color of one's skin.

Fine distinctions of brown were in play, but the social lines of demarcation were cast in simple black and white. Francis could have been considered a "mulatto" in America, given his biracial heritage, but he couldn't afford it in Savannah.

Our journey through Savannah's ghostly past unearthed a new ghost tale, albeit different in nature—the Justice and Indian ghost tale. The ghosts appearing in this story are actually truer in historical and social scope than any others, simply because the Yamacraw Indians who opened their arms and land to Oglethorpe and his English settlers actually believed in them. They were part and parcel of their daily life.

The spirits, as the story goes, were both liquid and material in nature, and it is difficult to discern which caused which. Old Joe Watson and his Yamacraw partying crew obviously possessed a keen fondness for the "Devil's Brew," as they called it.

The Evolution of a Ghost Story
Illustrated by George R. Hicks

One of the many ironies in the tale is we are not sure which form of spirit wreaked the most havoc—the liquid brew or Skee's ghost. It appeared to be a draw on every side.

We didn't say much about the demise of the slave Justice at Esteechee's hands, except that like most people of his lot in life, he was dealt a bad hand and happened to be the most available target for the Indian's revenge.

Finally, Willie and Nellie and the mythic Rene Rhondolia round out the book—two disparate stories reflecting the polar spectrum of ghost stories on Savannah's scene.

Nellie and Willie Gordon were two fortunate people madly in love through the thick and thin of their lives. Nellie was heartbroken when her husband died, suggesting she had more waiting for her on the other side of the divide than she did now that he was gone. Willie came to her on her deathbed, and the two departed into whatever eternity awaited them after death—one surely filled with their love.

Among the ghostly lot explored here, these two lovers may well be the only exception to the line in the Wallace Stevens poem: "There were ghosts that returned to earth…They were those from the wilderness of stars who expected more."[98]

Rene Rhondolia, though mythic and because he intersects at the tangents of our innate fears about various components of life, embodies such fears as uncontrollable and inexplicable forces of destruction. Rene is the beast just around the corner at night who preys on the most vulnerable within and among us. We never know when or where he will strike in the night. He is strong enough to kill the strongest of men, yet because he is less than us mentally, a boy-monster, his predilections are young girls, as if his predatory interest is aroused by those least able to defend themselves. The boy-giant also just happens to be the monster in the child's closet at night.

These people from the past have become the not-dead. It is difficult to discern whether they are cursed or the recipients of a strange luck. Like us all individually and in the total lot of the human race, they evolved from birth to the grave. Their memory and their ghosts are all that remain.

NOTES

CHAPTER 1

1. R.C. Finucane, *Ghosts: Appearances of the Dead* (New York: Prometheus Books, 1996), 5.
2. The sources for the Alice Riley ghost story are contained in the following primary documents: Thomas Christie letter to James Oglethorpe, December 14, 1734, Kenneth Coleman, Milton Ready, eds., *The Colonial Records of the State of Georgia: Original Papers, Correspondence to the Trustees, James Oglethorpe, and Others: 1732–1735* (Athens: University of Georgia Press, 1904. Reprint, 1982), 20:125–26 (hereafter *CRG*); Christie letter to Georgia Trustees, March 19, 1735, *CRG*, 273; and letter of Edward Jenkins to James Oglethorpe, January 20, 1735, *CRG*, 181–83. These are the only primary sources that discuss the events that make up the story and legend.
3. James Oglethorpe letter to the trustees, *CRG*, 41.
4. See Rodney Bain, "Oglethorpe's Forty Irish Convicts," *Georgia Historical Quarterly* 77, no. 2 (Summer 1977): 326–38. Bain points out the forty on the ship were originally considered to be convicts but were actually indentured servants originally bound for Philadelphia, a common port of entry for Irish immigrants.
5. The date is confirmed by the official list of early settlers from Georgia Trustees president John Percival's records. See Merton E. Coulter and Albert Saye, eds., *List of the Early Settlers of Georgia* (Athens: University of

Georgia Press, 1949, 2008), 95, 101, for Riley and White entries, as well as the others listed. See also Bain, "Forty Irish Convicts," 326; and Julie Ann Sweet, "The Murder of William Wise: An Examination of Indentured Servitude, Anti-Irish Prejudice, and Crime in Early Georgia," *The Georgia Historical Quarterly* 96, no. 1 (Spring 2012): 7.

6. Coulter and Saye, *List of Early Settlers*, 65. An extreme example of the prejudice and disgust felt for Irish indentured servants is seen in the entry for John Brown, who "killed his servant" for an unnamed reason, yet was "cleared" by management.

7. Sweet, "Murder of William Wise," 8–9. Sweet, a historian of colonial Georgia, discusses the possibilities of Riley and White's amorous relationship but not the ghost tale. As a historian, Sweet takes a critical look at the sources relating to Riley and White and does not assume they were necessarily lovers just because they were both implicated in the death of William Wise. Sweet does, in the end, however, admit that "the possibility exists and seems likely" they were lovers.

8. Lillian C. Bragg, "The Woman Savannah Hanged!," *Savannah Morning News Magazine*, April 19, 1959, 3–4. Bragg assumes this in her article, which has been the primary source, it seems, for this part of the Alice Riley ghost story.

9. Coulter and Saye, *List of Early Settlers*, 10.

10. Sweet, "Murder of William Wise," 17.

11. Christie, *CRG*, 125.

12. Thomas Christie letter, *CRG*, 125–26. Christie writes: "At the direction and influence of White, Alice brought a pail of water to the sick man's bed and set it down by his bedside. Then leaning over him, White took hold by the handkerchief, which he twisted till he was almost suffocated. Alice took hold of the top of his head and plunged his face into the pail of water. He being very weak, it soon killed him."

13. *CRG*, 126. Christie writes that Wise's personal effects were sold after his death and brought twenty pounds sterling, considerably less than he apparently was worth. He states: "[N]o doubt a great many [effects] were stolen by that villain who murdered him, which we never could find."

14. Sweet, "Murder of William Wise," 11.

15. Edward Jenkins letter to Oglethorpe, January 20, 1734, *CRG*, 183.

16. Some ghost books and tours that tell the Riley story argue she was hanged from an oak tree, not from the gallows. See James Caskey, *Haunted Savannah: America's Most Spectral City* (Savannah, GA: SubText Publishing, 2005, 2013), 145–47. This speculation does not appear to

be the case and is contrary to contemporary reports of the hanging. Edward Jenkins plainly states both Riley and White were taken to the "gallows" and hanged.

17. Quincy was appointed minister in July 1733. However, he was often sick and absent from the colony in Boston, where his family lived, and opposed many of the trustee policies. He asked to be removed in 1735, to the delight of the Trustees. He may or may not have been at the Riley and White executions, and if not, a local settler would have been with Riley. See Coulter and Saye, *List of Early Settlers*, 42.

18. The *List of Early Settlers* identifies William Grickson as the hangman (20). Grickson is an interesting figure in his own right, perfect for such a thankless job. He was twice sentenced to fifty lashes for deserting his post in the militia. He was discharged, married a woman named Janet Colstong in May 1734, apparently straightened up and was rewarded for his dubious service to the colony by being made hangman. A true rags to riches story, indeed! Regardless, the man surely knew how to receive and dole out punishment to others.

19. *"Teigh trasna ort fein"* is an Irish, or Gaelic curse, meaning "go across yourself!" It is a severe insult. www.insults.net/html/swear/irish.html.

20. Bragg, "The Woman Savannah Hanged!," 4–5. Bragg argues White made his way south of the city toward the backwater route out of the city, near what is now Isle of Hope. Bragg's article is largely undocumented, although she appears to have access to some original sources.

21. The source for the capture is Jenkins's letter, *CRG*, 182–83. Edward Jenkins was said to run a popular drinking establishment called "Jenkins Tavern." Undocumented legend, often repeated in the story of Alice and Richard, was Richard was initially sent to work as a servant for him. Jenkins found it difficult to find land he could cultivate, until he settled on an unnamed island. He left with his wife, Elizabeth, in fear of Spanish invasion in 1740, according to Coulter and Saye, *List of Early Settlers*, 80.

The Parker brothers, on the other hand, had a more colorful stay in Savannah. Henry, a linen draper, was made bailiff on four different occasions but was removed from his post in 1739 for drunkenness and complaining of the introduction of slaves into the colony. His brother, William, was a silversmith who was suspected of being a "Papist," according to *List of Early Settlers*, 39. Like others who settled the swampy area around Savannah, they had a difficult time finding suitable land.

22. Sweet, "Murder of William Wise," 17.

23. Thomas Christie letter, *CRG*, 126.
24. Caskey, *Haunted Savannah*, 146–47.

CHAPTER 2

25. *Merriam-Webster Dictionary*, www.merriam-webster.com/dictionary/giant.
26. Caskey, *Haunted Savannah*, 95.
27. "The Scariest Places on Earth (Savannah, Georgia)," *You Tube*, http://www.youtube.com/watch?v=hby4KVSEvwg.
28. "Walk Your Scaredy-Pants Off," http://www.cnn.com/2003/TRAVEL/10/30/sprj.ft03.hauntedsavannah/.
29. See Caskey, *Haunted Savannah*, 37–39.
30. This understanding of scapegoating myths is indebted to the thought of Rene Girard, who has shed valuable light on the subject of cultural myths in the modern era. See James G. Williams, ed., *The Girard Reader* (New York: Crossroad Publishing Co., 1996).
31. *The Greek New Testament*, 3rd ed., eds. Kurt Aland, Mathew Black, Carlo M. Martini, Bruce M. Metzger and Allen Wikgren, trans. Michael Harris (New York: United Bible Society, 1975), 137–38.

CHAPTER 3

32. Hilda Doolittle, *Tribute to Freud*, 2nd edition (Bloomington: Indiana University Press, 1985 [1956]), 42.
33. The EVP is affectionately known on a popular trolley ghost tour as "the Molly file."
34. The primary source for the history of the Sorrel family is Carla Ramsey Weeks, *The Sorrels of Savannah: Life on Madison Square and Beyond*, (Outskirts Publishing: Denver, CO: 2012). See also Robert M. Myers, *Children of Pride* (New Haven: Yale University Press, 1972); and *History of the Independent Presbyterian Church and Sunday School* (Savannah: George N. Nichols, Printer and Binder, 1882).
35. Weeks, *Sorrels of Savannah*, 7. Weeks cites official family biographer John Freymann as saying Eugenie "was quite possibly a member of the *gens de couleur libre*."
36. Ibid., 98.
37. Ibid., 87–99.
38. Ibid., 93–94.

39. Fay A. Yarborough, "Power, Perception, and Interracial Sex: Former Slaves Recall a Multiracial South," *Journal of Southern History* 71, no. 3 (August 2005): 566.

40. Myers, *Children of Pride*, 570–71.

41. Caskey, *Haunted Savannah*, 250–51.

CHAPTER 4

42. Sources for this chapter include: Stacy A. Cordery, *Juliette Gordon Low: The Remarkable Founder of the Girl Scouts* (New York: Penguin Books, 2012); Charles J. Johnson, "William Washington Gordon (1796-1842)," *Georgia Encyclopedia* (accessed online April 8, 2014); Gordon Family Papers, 1810–1968, Southern Historical Collection #2235, University of North Carolina at Chapel Hill; Margaret Wyat Debolt, *Savannah Spectres: And Other Strange Tales* (Norfolk, VA: The Donning Co., 1984, 1995), 61–66; Caskey, *Haunted Savannah*, 63–67.

43. Debolt, *Savannah Spectres*, 64.

CHAPTER 5

44 Finucane, *Ghosts: Appearances of the Dead*, 92.

45. All of the information relating to Joseph Watson and the Skee affair comes from the following sources: Letter of Samuel Eveleigh to James Oglethorpe, October 19, 1734, *CRG*, 87–88; Letter of Thomas Causton to the trustees, January 16, 1735, *CRG*, 172–76; Letter of John Musgrove to James Oglethorpe, January 24, 1735, *CRG*, 98; Letter of Reverend Samuel Quincy to Peter Gordon, March 3, 1735, *CRG*, 20: 246; Letter of Thomas Causton to Trustees, March 10, 1735, *CRG*, 258; Letter of Thomas Causton to James Oglethorpe, March 24, 1735, *CRG*, 283–84; Letter of Robert Parker to Robert Hicks, June 3, 1735, *CRG*, 371–72. See also the account by Julie Sweet, *Negotiating for Georgia: British-Creek Relations in the Trustee Era* (Athens, GA: University of Georgia Press, 2005), 66–77.

46. Coulter and Saye, *List of Early Settlers*, 101.

47. Causton letter to the Georgia Trustees, January 16, 1735, *CRG*, 20:172.

48. Ibid.

49. Bill Grantham, *Creation Myths and Legends of the Creek Indians* (Gainesville: University of Florida Press, 2002), 39; Gary Varner, *Ghosts, Spirits & the Afterlife in Native American Folklore* (Raleigh, NC: Lulu Press, 2010), 56.

50. John R. Swanton, *Creek Religion and Medicine* (Lincoln: University of Nebraska Press, 1928, reprint, 2000), 480.

51. This material is taken from accounts of the nature of Creek Indian beliefs about the world they inhabited. See Robbie F. Ethridge, *Creek Country: The Creek Indians and Their World* (Chapel Hill: University of North Carolina Press, 2003), and Bill Grantham, *Creation Myths and Legends of the Creek Indians* (Gainsville: University of Florida Press, 2002).

52. James Adair, *History of the American Indians*, 5, http://www.olivercowdery.com/texts/1775Adr1.htm.

53. Ibid., 150.

54. This Creek Indian phrase literally means, "The days appointed, or allowed, to him, were finished." See Swanton, *Creek Religion and Medicine*, 512.

55. John Musgrove in letter to trustees, January 24, 1735, *CRG*, 20:197.

56. Sweet, *Negotiating for Georgia*, 68. Sweet argues Esteechee's killing of the slave Justice was an accident, not an intentional act of retribution against Watson. However, it need not be seen as an accident according to the law of blood revenge practiced by these Indians. See Ethridge, *Creek Country*, which states: "In the law of blood revenge, when someone caused the death of another person, the clan of the dead person had the duty and the right to kill the slayer *or a member of the slayer's clan*," (emphasis mine), 231. Justice's murder is not necessarily an accident from the point of view of the Indian, Esteechee. Even as a slave Justice was likely viewed as part of the trading post clan of John Musgrove and his partner, Watson.

57. See "Discoveries at the Post: Archeologist Speaks to Historical Society about Discoveries at Colonial Trading Post on Savannah River," *Savannah Now*, http://savannahnow.com/stories/071503/LOCgrangelecture.shtml, and "Georgia Port to Fund New Musgrove Exhibit," *Savannah Now*, http://savannahnow.com/stories/071304/2299504.shtml.

CHAPTER 6

58. Gary Snyder, "Old Bones," *Mountains and Rivers Without End* (Berkeley, CA: Counterpoint Press, 1996), 10.

59. Mark C. Taylor, "Sacred Bones," *Cabinet* 28 (Winter 2007–08), http://cabinetmagazine.org/issues/28/taylor.php.

60. See Rudolf Otto, *The Idea of the Holy*, trans. W.J. Harvey (New York: Oxford University Press, 1923; 2nd edition, 1950).

61. Julie Ann Sweet, "Will the Real Tomochichi Please Come Forward?," *American Indian Quarterly* 32, no. 2 (Spring 2008): 161.

62. The map can be found at http://www.loc.gov/resource/g3923c.la000085/.

63. Dolores Boisfeuillet Floyd, "The Legend of Sir Walter Raleigh at Savannah," *Georgia Historical Quarterly* 23, no. 2 (June 1939): 103–121.

64. William de Brahm, *History of the Province of Georgia: with Maps of Original Surveys,* (Wormsloe, GA, [1757] 1849), Georgia Historical Society. Also cited in Floyd, "Legend of Sir Walter Raleigh," 106.

65. Floyd, "Legend of Sir Walter Raleigh," 111–21.

66. The Irene Mound site was an Indian burial complex located five miles northwest of Savannah on the banks of the river basin. It dated back to 1100 AD and was abandoned before the Georgia colonists arrived in 1733. Tomochichi likely knew of it and probably would have included it in the burial grounds of his ancestors, and the settlers knew of it as well. Yamacraw Village was located near the mound, as well as the Musgrove Trading Post. See Mark Williams, "Irene Mounds." *New Georgia Encyclopedia,* August 29, 2013 (accessed December 2013), http://www.georgiaencyclopedia.org/articles/history-archaeology/irene-mounds.

67. Thomas Causton, letter to his wife, *CRG*, 16.

68. Robin B. Williams, "The Challenge of Preserving Public Memory: Commemorating Tomochichi in Savannah," *Preservation Education & Research* 5 (2012): 2.

69. Allen D. Chandler, ed., *The Colonial Records of the State of Georgia: Stephens' Journal 1737–1740* (Atlanta, GA: The Franklin Printing and Publishing Co., 1906), 4:428.

70. Walter Glasco Charlton, *Dedication of the Memorial to Tomochichi in Wright Square, Savannah, Georgia, April 21, 1899* (Savannah: Georgia Society of Colonial Dames, 1899), 11. Georgia Historical Society, Rare Pamphlet Collection.

71. Sources for Victorian burials are: "William Henry Harrison and the Body Snatchers," Gravely Speaking, http://gravelyspeaking.com/2011/12/11/william-henry-harrison-and-the-body-snatchers/; "Victorian Morning Fashions," Friends of Oak Grove Cemetery, http://friendsofgoakgrovecemetery.org/victorian-mourning-fashions./; Sean O'Keefe, "The Widow of Windsor—A Queen In Mourning," http://www.royalcentral.co.uk/blogs/the-widow-of-windsor-a-queen-in-mourning-9585; Loretta M. Allrangues, "Funerary Practices in the Victorian Era," *Morbid Outlook*, http://www.morbidoutlook.com/nonfiction/articles/2003_04_vicdeath.html; Dan Meinwald, "Memento

Mori: Death and Photography in Nineteenth Century America," http://vv.arts.ucla.edu/terminals/meinwald/meinwald1.html; Kyshah Hell, "Victorian Mourning Garb," *Morbid Outlook*, http://www.morbidoutlook.com/fashion/historical/2001_03_victorianmourn.html; Jeremy Grange, "Resusci Anne: The Mona Lisa of the Seine," BBC News, http://www.bbc.com/news/magazine-24534069.

72. Edgar Allan Poe, "The Premature Burial," *The Collected Works of Edgar Allan Poe* (New York: Random House, 1992), 258.

73. Ibid.

74. Thornwell Jacobs, "Who Is This That Cometh to Disturb My Rest?," in Paul S. Hudson, "The Special Relationship—Georgia and the Remains of General Oglethorpe," *Contemporary Review*, 263/1532 (September 1993), 145.

75. All information is taken from Hudson, "The Special Relationship," 140–46.

76. Ibid., 143.

77. Hermes was the god in Greek mythology who served as a guide between the living and the dead.

78. Hudson, "The Special Relationship," 142.

79. Ibid., 146.

CHAPTER 7

80. *The Merchant of Venice*, in *The Norton Shakespeare Based on the Oxford Edition*, eds. Stephen Greenblatt, W. Cohen, J.E. Howard, K.E. Maus. (New York: W.W. Norton & Company, 1999), 1116.

81. Most of the accounts of the Stark-Minis affair as told online by ghost sites tell the story incorrectly. Even the blog on the Travel Channel site about the Moon River Brewery is incorrect, saying, "Stark was drinking heavily and spewing disparaging remarks against the doctor. Dr. Minis walked into the bar, saw Stark and shot him." http://www.travelchannel.com/tv-shows/ghost-adventures/articles/moon-rivers-haunted-history. Another site represented by RIP Hunters states: "The story goes that Stark was drinking at the bar in the First City Hotel began making remarks about another patron, Dr. Minis. Dr. Minis later arrived and shot Stark in the bar." http://www.meetup.com/riphunters/events/17574128/.

As we shall see, Stark was shot to death in the City Hotel, which is now Moon River Brewing Co., but that is not the bar where he first began his verbal attack on Minis nor is it exactly how the shooting went down on August 10, 1832.

82. This origin of the dispute is taken from Thomas Gamble, *Savannah Duels and Duelists: 1733–1877* (Savannah, GA: Review Publishing and Printing Co., 1923), 194.

83. Some who tell this tale are wary to mention the exact nature of Stark's insults of Dr. Philip Minis because of their derogatory ethnic nature. This is essentially the case with James Caskey's account of the story in *Haunted Savannah*, 41–46, which states: "Stark went on to call the good doctor several unprintable insults, all relating to Dr. Minis' Jewish ancestry."
Without knowing what those insults were, however, we are unable to fully understand the nature of the men's conflict and why Minis was so insistent Stark offer an apology. We cite these insults not because of a superfluous indulgence but because they reveal the exact nature of the insults that provoked Minis to his due anger, not to mention his final response.

84. The accounts of the Stark/Minis affair are taken from the following primary sources: Dr. Richard D. Arnold, *Colligere: Diary Commenced, July 2nd, 1832*, 1–18. Excerpt, August 9–16, 1842, from the diary of Dr. Richard Arnold 1832-1838. Typewritten transcript from the Original at Duke University. Richard Dennis Arnold Papers, MS 27, The Georgia Historical Society, Savannah, Georgia. ; and [NA], "The Stark-Minis Duel," *The American Jewish Archives Journal* 55, no. 1 (1955), 73–81, which contains excerpts from a letter of Minis's sister, Sally, and an account in the journal of Robert Habersham.

85. Kenneth S. Greenberg, "The Nose, the Lie, and the Duel in the Antebellum South," *American Historical Review* 95, no. 1 (February 1990): 67.

86. See Bertram Wyatt-Brown's classic study of southern honor, *Southern Honor: Ethics and Behavior in the Old South* (New York: Oxford University Press, 1982, reprint 2007).

87. Christopher G. Kingston and Robert E. Wright, "The Deadliest of Games: The Institution of Dueling," *Southern Economic Journal* 76, no. 4 (2010): 1094–1106.

88. On this aspect of male honor, see Greenberg, "The Nose, the Lie, and the Duel."

89. *Merchant of Venice*, 1099.

90. Ibid., 1116.

91. Arnold's journal forms the most comprehensive account of the events that took place; we follow his outline throughout the chapter. James Caskey essentially dismisses Arnold's account as being that of a biased friend, *Haunted Savannah*, 42–43. However, Arnold was a newspaper publisher

(*Daily Georgian*) with an acute eye for detail. His account contains no hint of bias against Stark.

92. *Merchant of Venice*, 1094.

93. See Habersham's remarks in, "The Stark-Minis Duel," 80–81.

94. *Merchant of Venice*, 1116.

95. Arnold, *Colligere*, 12–13. The incident occurred the day after the City Hotel shooting and clearly appears to be based on the events that transpired on August 9–10 involving Stark and Minis.

96. "The Stark/Minis Duel," 80.

97. "Savannah 10th August 1832," *Savannah Anti-Dueling Association Constitution and Minutes, 1827–1838*, MS 680, Georgia Historical Society, Savannah, Georgia.

CONCLUSION

98. Wallace Stevens, "Large Red Man Reading," *Stevens: Collected Prose and Poetry* (New York: Library Classics of the United States, 1997), 365.

ABOUT THE AUTHORS

Michael Harris is a private researcher and writer in Savannah, Georgia. He is currently the Ghosts and Gravestones Trolley Tour (Old Town Trolley Tours, Savannah, Georgia) supervisor. He also has a BA in history and a PhD in New Testament studies. He loves to read and listen to good ghost stories and has an abiding interest in unusual cultural phenomena.

Linda Sickler is an award-winning reporter for the *Savannah Morning News*. She is also a licensed tour guide who loves Savannah's people, history, restaurants, architecture, flora and fauna. Having conducted ghost tours for several years, she is a firm believer that something is "out there"…or ought to be.